IMAGES
of America

BETHLEHEM

Susan E. Leath

ARCADIA
PUBLISHING

Published by Arcadia Publishing
Charleston, South Carolina

Printed in the United States of America

Library of Congress Control Number: 2011928028

For all general information, please contact Arcadia Publishing:
Telephone 843-853-2070
Fax 843-853-0044
E-mail sales@arcadiapublishing.com
For customer service and orders:
Toll-Free 1-888-313-2665

Visit us on the Internet at www.arcadiapublishing.com

This book is dedicated to history lovers everywhere. All of the author's royalties will be donated to the Bethlehem Historical Association.

IMAGES
of America

BETHLEHEM

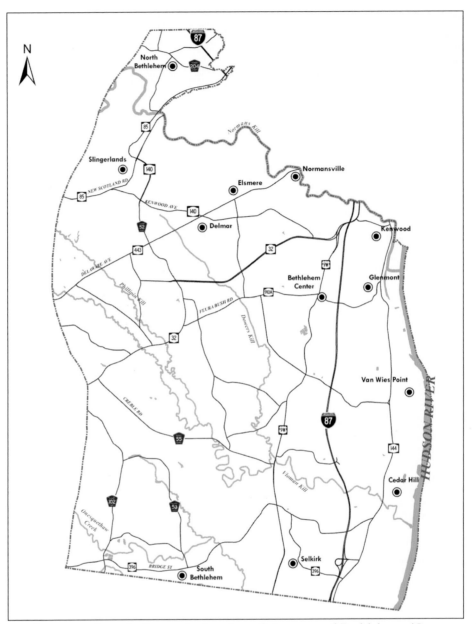

The modern map above indicates the hamlets of the town of Bethlehem. (Courtesy of Robert Leslie.)

ON THE COVER: Members of the Winne family gather about 1900 at the family homestead that was located on Delaware Avenue at Village Drive. Esley Winne, the man standing on the left with the straw hat, built the Adams Hardware Building at the Four Corners about 1905. In later years, John Winne, the youngster in the back who is seated on a horse, ran the dairy farm at the homestead until 1930. Nan Winne, second from left in black, lived at the Village Drive home all of her life. She died in the late 1970s when she was in her 90s. (Courtesy of the Town of Bethlehem.)

CONTENTS

ACKNOWLEDGMENTS

Many people encouraged me in the creation of this book. To all of you, my sincere thanks. Special thanks go to former town historians Allison Bennett and Joe Allgaier; Bethlehem Historical Association members Valerie Thompson and Susan Haswell; town supervisor Sam Messina and members of the town board; Susan Alexander; Rob Leslie; Freddie Dunn; Sharon Schultz; Rebekah Mower and Abby Henry at Arcadia Publishing; Perfect Blend and Java Jazz for a nice change of scenery; and, of course, my family for putting up with my takeover of the dining room table.

Unless otherwise noted, all images appear courtesy of the Town of Bethlehem photograph archive (TOB) or the Bethlehem Historical Association (BHA).

INTRODUCTION

"So thickly placed throughout the town are these numerous hamlets that their description substantially constitutes the modern history of the locality."

—Amasa Parker, *Landmarks of Albany County*, 1897

Delmar, Elsmere, Glenmont, Selkirk, Slingerlands, North Bethlehem, and South Bethlehem—these are the modern hamlets of the town of Bethlehem, New York. Beckers Corners, Bethlehem Center, Cedar Hill, Wemple, Houcks Corners, and Normansville are less familiar names that turn up on modern maps. Kimmeys Corners, Adamsville, Normanskill, Lower Hollow, Upper Hollow, Mallorys Corners, Jaynes Corners, Jericho, Kenwood, and many others are historic names that have fallen out of modern use. Woven together, they tell the larger story of the town of Bethlehem, illustrated here with historic photographs.

Hamlets are communities of people who have gathered to live near each other at a crossroads, a store or mill, blacksmith shop or post office. They are often named for the prominent family there or a geological feature. Adamsville, named for Nathaniel Adams, and Normansville, named for its location on the Normanskill, are examples. Scattered throughout the town, hamlets make up the town of Bethlehem. In years gone by, the countryside surrounding the hamlets was occupied by the farms and farmers that were the backbone of Bethlehem's rural economy. Modern Bethlehem still has its hamlets, now surrounded by suburban housing development and commercial and agricultural enterprises.

Before there were any hamlets, Native Americans made use of the natural resources of the countryside that was to become Bethlehem. Archaeologists have identified a significant seasonal village located near the mouth of the Vlomankill at the Hudson River in the southern part of town. Evidence suggests it was occupied over thousands of years. Over the years, as farmers tilled the soil, Native American stone tools and artifacts have turned up in many locations in town. In historic times, both the Mohicans and Mohawks claimed the area.

Profound change began in September 1609 with Henry Hudson's exploration of the river that was to bear his name. Hudson, an Englishman, sailed for the Dutch aboard the *Half Moon* looking for a northwest passage to Japan and China. Instead, in the shallow waters near the northern reaches of the river, he and his crew had friendly encounters with the Mohican Indians and observed a wealth of natural resources, including fish, beaver, timber, and fertile soils. The question of whether Henry Hudson set foot on Bethlehem's shores cannot be definitively answered. It is enough to say that Hudson and crew were in the area and reported back to the Dutch about their experiences, leading directly to the Dutch settlement that characterized early Bethlehem.

Killiaen Van Rensselaer, a wealthy merchant from Amsterdam and a director of the Dutch West India Company, was instrumental in early European settlement. In order to foster immigration, the Dutch West India Company granted Van Rensselaer the manor of Rensselaerwyck, of which he was patroon (proprietor). On August 13, 1630, Van Rennselaer's agent made the first of several land purchases from the Mohican Indians. By the 1660s, the manor covered more than 770,000

acres on both sides of the Hudson River, including all of the future site of the town of Bethlehem. Van Rensselaer and his heirs maintained their control of the manor through the British takeover in 1664 and the American Revolution on through the Anti-Rent War of the 1840s.

The earliest reference to Bethlehem is found in court documents dating to 1649, which refer to the small settlement at the confluence of the Hudson River and the Vlomankill in the southeastern part of town. Early settlers include Albert Bradt, a Norwegian for whom the Normanskill is named who arrived in 1637, and Teunis Slingerland, who turns up in early records in 1654 as a "Trader at Beverwyck" (Beverwyck later became the city of Albany) and whose descendants established the Bethlehem hamlet of Slingerlands. During the 1700s, Bethlehem was part of the west manor of Rensselaerwyck, or simply the West Manor. After the American Revolution, in 1788, the town of Watervliet was organized, from which the town of Bethlehem was created on March 12, 1793. In 1832, Bethlehem's boundaries changed again when the town of New Scotland was created from its western half.

Early settlement by farmers and sawmill workers happened primarily along the town's waterways, including the Hudson River, which forms Bethlehem's eastern border; the Normanskill to the north; and the Vlomankill to the south. (The word *kill* translates as "stream" or "creek" in Middle Dutch.) As the population grew, farmers and workers moved inland along the trade roads, which developed into crossroads and corners, helped along with the development of toll roads. One example is Peter McHarg, who in 1790 rented 223 acres along what is now Feura Bush Road (across from today's Bayberry Road) from the patroon for a yearly rent of 16 bushels of wheat, one day's service with a team, and four fat fowl. Another is John Haswell, who arrived in 1772 with his wife and 10 children and rented 300 acres from the patroon near present-day Feura Bush Road and Murray Avenue.

Bethlehem's hamlets were starting to develop. With the farmers came gristmills and sawmills, carpenters and blacksmiths, hotels and taverns, and schools and shops. Over the years, other natural resources were exploited, including the molding sand found under the topsoil and the ice that formed in the rivers.

Bethlehem's proximity to the Hudson River was one of the keys to its success as an agricultural community. Local farmers' cash crops, such as wheat, hay, oats, and apples, could be readily sent down to the docks for river shipment, especially to the markets of Albany and New York City. In later years, ice was added to the commodities shipped to New York City from Bethlehem. By the late 1800s and early 1900s, wealthy families from Albany established summer estates along the Hudson River.

For many years a rural agricultural town, Bethlehem began another era of change with the coming of the railroads in the 1860s. The arrival of the Albany & Susquehanna Railroad in 1863—connecting Elsmere, Delmar, and Slingerlands to Albany—brought the beginnings of suburbanization to Bethlehem. When the Delaware and Hudson Company leased the line, these stations allowed an easy commute to Albany for work and shopping. Many of the Victorian homes in the hamlet of Slingerlands were built for Delaware and Hudson employees. In the southern part of town, the West Shore Railroad came through in the 1870s, bringing further development to the hamlets of South Bethlehem and Selkirk. Suburbanization continued to grow in the early part of the 20th century and blossomed after World War II.

Today, Bethlehem is a robust town with an appreciation of its unique history and its unique hamlets. Enjoy the pictures that follow, let them be the warp and weft, weaving the tapestry of Bethlehem's history.

A further note: A challenge in organizing this book was placing photographs in a particular chapter. Hamlet boundary lines are fluid, changing over time and seemingly at the whim of the United States Post Office Department. It is simple to place a picture of the Four Corners in Delmar or one at Babcocks Corners in Bethlehem Center. Not so simple are the scattered farmhouses or historic hamlets that are no longer recognized. As a compromise, the difficult ones were placed within their modern zip codes.

One

HURSTVILLE AND
NORTH BETHLEHEM

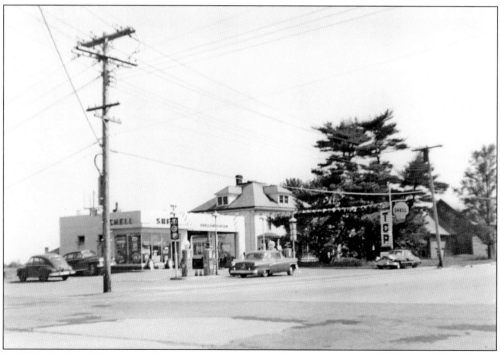

In 1861, William Hurst settled near the intersection of New Scotland and Whitehall Roads and built his hotel on the site of an old log tavern on the northwest corner. Shortly thereafter, the area became known as Hurstville. Shown here is the southeast corner in 1953 before the area was annexed by the City of Albany in 1963. George Miller's house and barn can be glimpsed in the background. (TOB.)

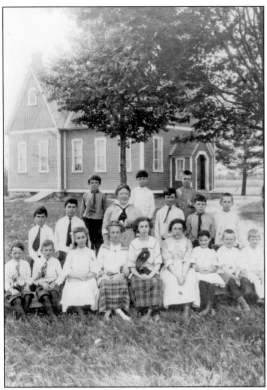

In 1915, pupils of District School No. 13 at Hurstville surround Miss Clancy, their teacher. This common district school was located on New Scotland Road near where the New York State Thruway is today. When centralized, it was likely students went to the Guilderland Central School District or to Albany city schools. (TOB.)

Even as late as 1953, the barn on George Miller's property on the southeast corner of Whitehall and New Scotland Road calls to mind a rural atmosphere. However, neighborhoods have already filled in to the north and east, and the New York State Thruway officially opened on the other side of the barn in 1954. The barn has since been torn down. (TOB.)

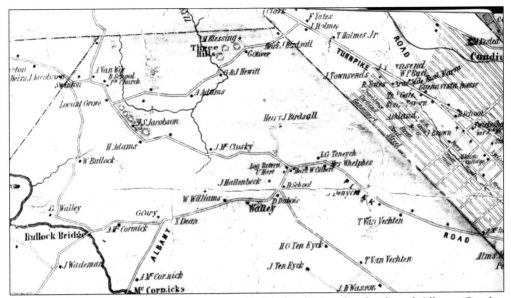

The northern part of Bethlehem has ties to Guilderland, New Scotland, and Albany. On this 1851 map, note the Log Tavern of Hurstville. Bulluck's Bridge is where today's New Scotland Road crosses the Normanskill into Albany. Also note the church and school of North Bethlehem at the top right. (TOB.)

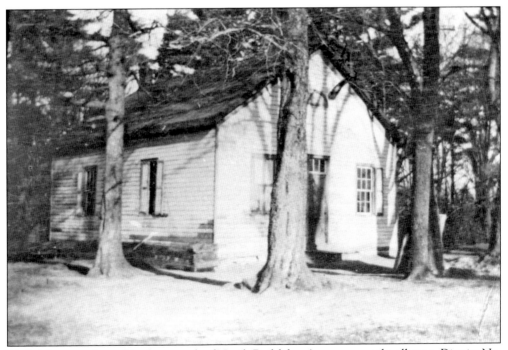

Little is known about this photograph of North Bethlehem's one-room schoolhouse, District No. 14. It appears to be tucked in the woods and in poor condition. Old maps indicate that District No. 14's school was located on Krumkill Road, near the intersection with Russell Road. Before centralization in the 1930s and 1940s, every hamlet had its own common school. This one-room school was incorporated into the Guilderland Central School District. (TOB.)

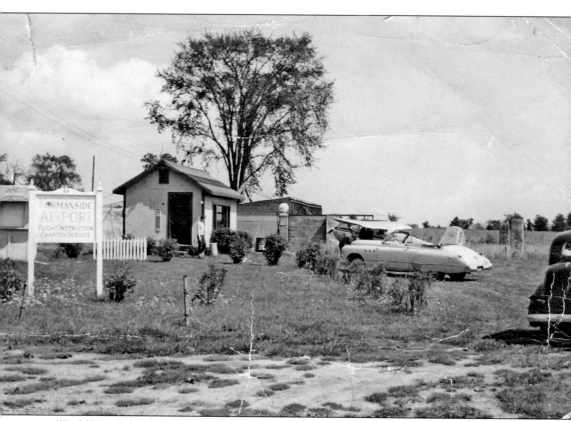

World War II fueled an interest in aviation, and Bethlehem enjoyed a boom in small airports in the 1940s. The Tri-Village Airport, established by Ralph Mosher, and the Normanside Airport, founded by Chiore and Santo Italiano, began in 1947 in proximity to each other in the New Scotland Road–Blessing Road area. Normanside closed in 1954; Tri-Village continued until 1984. The South Albany Airport was established by William VanValkenburg in 1942 and still operates today off Creble Road. Also in the early 1940s, Shelly Edmundson had a small airport in Selkirk, near Route 9W and Pictuay Road, close to the town's southern border. Turf strips for taking off and landing planes were the norm for these rustic airfields. Shown here is the Normanside Airport. (TOB.)

Two

SLINGERLANDS

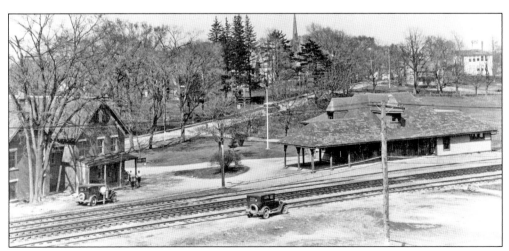

The rear of the Slingerlands Station is seen about 1900. New Scotland Road and the steeple of the Methodist church are in the background. To the right is the District No. 9 schoolhouse. In 1863, the Albany & Susquehanna Railroad was built from Albany through Adamsville and Slingerlands and on to New Scotland. Eventually, the line would reach Binghamton. Investors were looking to bring coal to Albany from northeastern Pennsylvania. With its scheduled trips to Albany, the railroad would bring the beginning of suburbanization to Bethlehem. (TOB.)

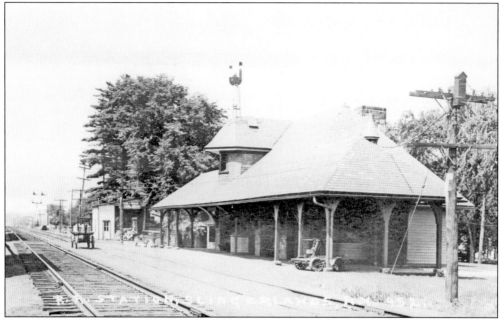

A trackside view of the Slingerlands railroad station leads the eye westerward toward New Scotland, the next stop on the Albany & Susquehanna Railroad. The Albany & Susquehanna tracks were leased by the Delaware and Hudson Company in 1870. The January 14, 1869, schedule notes that the train departs Slingerlands at 8:01 a.m. and arrives 19 minutes later in New Scotland. Binghamton would be reached 142 miles later at 7:50 p.m. (TOB.)

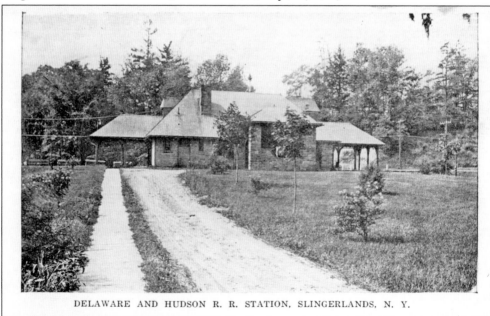

DELAWARE AND HUDSON R. R. STATION, SLINGERLANDS, N. Y.

This early postcard view shows the Slingerlands Station from New Scotland Avenue. After passenger service ceased in 1933, the Slingerlands Fire Department, established in 1928, used this impressive stone building as its station. Community events were held here as well. The building was demolished in the 1960s to make way for a new fire station. (TOB.)

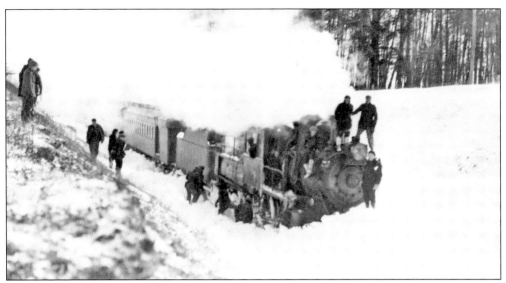

Snow clogs the tracks of the D&H west of Slingerlands on Saturday, February 14, 1914. The No. 610 local passenger train out of Albany became snowbound at Benders Crossing. The *Altamont Enterprise* reports that passengers to Voorheesville walked home, and another group returned to the Slingerlands Station, where they remained until Sunday afternoon. (BHA.)

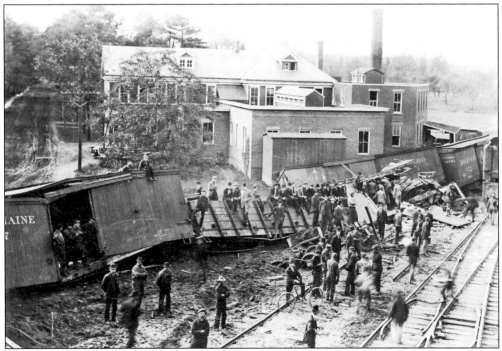

While bringing much-needed transportation, trains also brought dangers. This wreck occurred on Saturday, October 12, 1907. The Slingerlands Printing Company is in the background. The *Altamont Enterprise* reports that a brake beam on one of the 30 cars of an eastbound freight train broke, causing it to jump the switch. Thirteen other cars followed it over the embankment. "The cars were filled with coal, flour, kerosene, linseed oil, paper, cereals, etc., and the whole cargo became involved in an explicable mass." (TOB.)

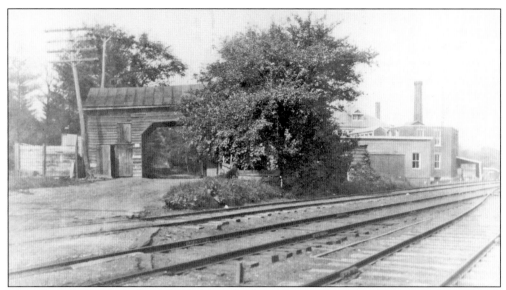

The Albany, Rensselaerville, and Schoharie Plank Road opened in 1859. The original road followed the same path as parts of modern-day New Scotland and McCormack Roads. The boards that paved the plank roads were believed to be an improvement over the dirt and sand of previous road building. However, the wooden planks had a short life span of only five to 10 years. Most roads eventually were graveled and or later paved with macadam. The Slingerlands tollgate was removed in 1908. (TOB.)

RESIDENTIAL SECTION, SLINGERLANDS, N. Y.

This c. 1920 postcard shows New Scotland Road looking east, probably near Font Grove Road. With its smooth, paved street, sidewalk, and mature trees, the postcard presents a lovely vista. Font Grove was a 600-acre estate amassed by Albany businessman Col. James Hendrick after his marriage to Slingerlands native Anna Wands in 1858. The estate included a thriving dairy farm, greenhouses for his horticulture business, 12 houses, and assorted barns and outbuildings. The estate was broken up upon his death in 1899. (TOB.)

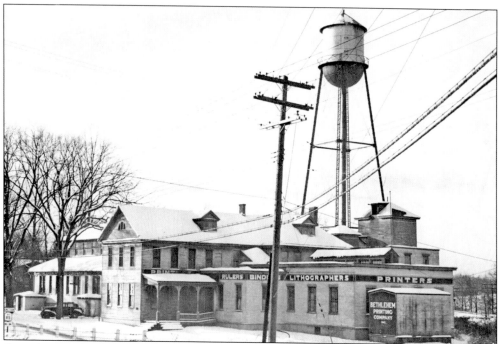

Cornelius H. Slingerland established the Slingerland Printing Company in 1879. Conveniently located near the D&H Railway line, the company specialized in printing for the railroad, including timetables and other railroad forms. Posters, election forms, and items like paper, envelopes, and twine rounded out the business. In 1935, it was acquired by the Burland Printing Company, which continued the Slingerland name. The above photograph shows the plant after 1940, when the company dissolved and the plant was sold to the Bethlehem Printing Company. In 1946, the building was converted to apartments. Below, a group of employees poses near the porch in 1909. The donor of the photograph is Ellen Figel, whose grandfather Charles Pierson is sitting in the first row, third from the right. (Both, TOB.)

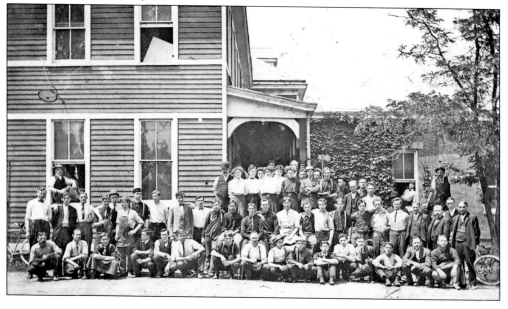

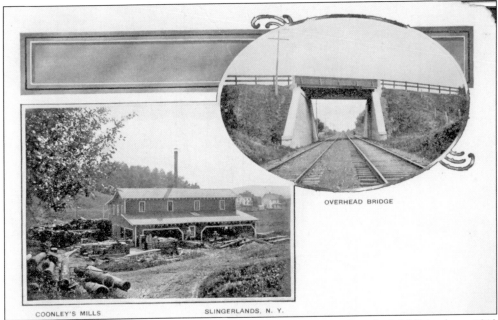

COONLEY'S MILLS SLINGERLANDS, N. Y.

OVERHEAD BRIDGE

Piles of timber await the saws that will turn them into lumber at Coonley's Mill in the c. 1910 postcard above. Coonley's also had a cider mill for local apples in the fall months. The mill was located on the southwest side of Kenwood Avenue, near today's Cherry Avenue. The layout of the roads in the area of Kenwood and Cherry Avenues has changed significantly. In the early years, Kenwood and Cherry Avenues converged just before the overhead bridge, with the road carrying on as McCormack Road (then part of the Albany, Rensselaerville, and Schoharie Plank Road). In more recent times, Kenwood continues westward, south of the tracks to New Scotland Road, and the Cherry Avenue Extension heads north. The picture below is the same bridge seen from Kenwood Avenue in the mid-1960s, just before it was removed, creating a dead end at Bridge Street. (Both, TOB.)

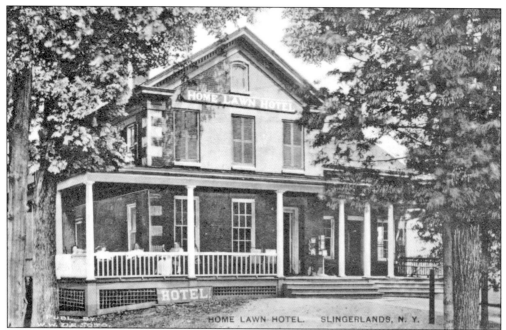

Accommodating travelers and summer boarders, the Home Lawn Hotel enjoyed a prominent location in the hamlet. At the turn of the 20th century, proprietor Rufus Zelie hosted local banquets and dances as well automobile and sleighing parties from Albany. Shown here in a c. 1910 postcard, the hotel was built about 1850. In the 1920s, it gained notoriety for selling liquor during Prohibition. The building is now a private residence on New Scotland Road. (Courtesy of Janet Vine.)

One of Slingerlands's oldest commercial buildings, this sturdy brick structure on New Scotland Road near the railroad underpass has seen a number of uses over the years, including as a general store and post office. The building has not changed too much today; even the "skinny" building at the far right is still standing, although not connected to the store anymore. (Courtesy of Shirley Martin.)

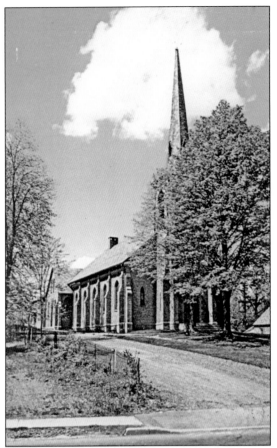

The Slingerlands Community United Methodist Church is a Slingerlands landmark. In 1830, a group of Methodists formed in Adamsville (now Delmar). In 1871, a dispute over where to build a new church led to a split, and the Slingerlands church was established. By December of that year, the new church building in Slingerlands was dedicated. Albert I. Slingerland donated the land and building. The bell tower features a Meneely bell cast in West Troy, New York, in 1877. The postcard at left is from about 1960. In the postcard below, patriotic citizens raise the flag on April 6, 1918, one year after the United States declared war against Germany. Clearly seen on the right is the church parsonage. Albert I. Slingerland used materials left from the old Adamsville church to construct the house in 1872. He offered the lot and house to the church for $1,700 in April 1873. (Both, TOB.)

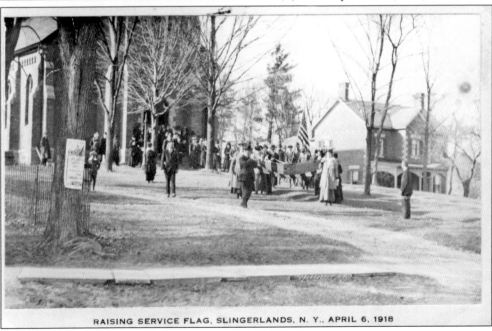

RAISING SERVICE FLAG, SLINGERLANDS, N. Y., APRIL 6, 1918

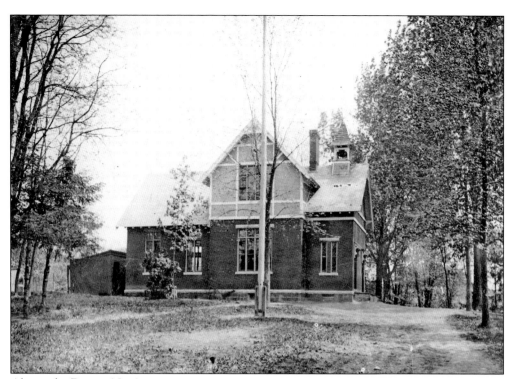

Above, the District No. 9 school stands ready to receive students. Shown above about 1900, this school building was torn down in 1908 and a new, larger structure was built on the site. While the new school was being built, students attended classes at the Methodist church across the street. The school still stands today at 1500 New Scotland Road. In 1930, District No. 9 centralized with others to form the Bethlehem Central School District. The last eighth grade graduated here in 1931, with first through sixth continuing until 1946. At that time, the building was converted to apartments by the Zautner family. At right, members of the 1907 graduating class stand in front of the old brick school. Note the students looking out from the window. (Both, TOB.)

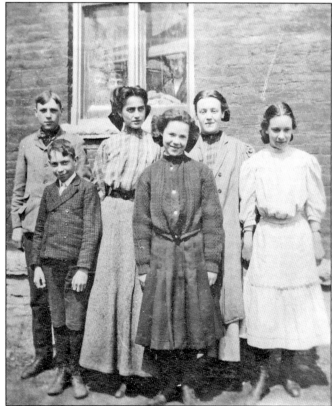

Shown here just before it was torn down in 1982, this home was built by William Henry Slingerland in the 1870s on what is now the Mangia Restaurant site. An influential man in the hamlet, William Henry was a surveyor and civil engineer who organized the Suburban Water Company. He established the post office here in 1852 and was the postmaster for 20 years. Slingerland also served in the New York State Legislature. (TOB.)

William H. Slingerland Jr. served as town supervisor from 1894 to 1895. His ancestor, Teunis Slingerland, first appears in colonial records in 1654, identified as a trader at Beverwyck. Teunis's farm was located along the Normanskill near that of early settler Albert Bradt, in what is known today as Slingerlands. Teunis was the first of a long line of Slingerland descendants to make their marks in Bethlehem and nearby New Scotland. (TOB.)

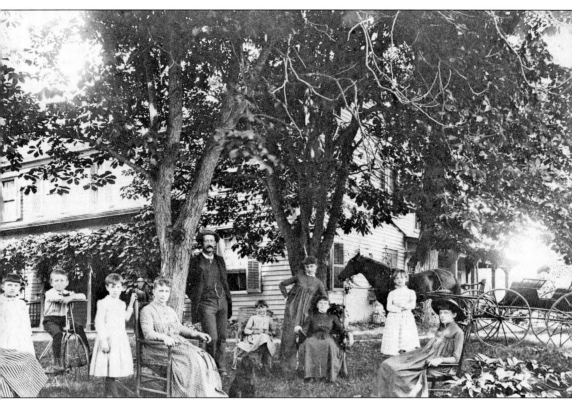

Members of the Slingerland family gather in front of the family homestead about 1890. The rear portion of the New Scotland Road house dates to about 1790, when John Albert Slingerland leased land from the Van Rensselaer patroon. John Albert married Leah Britt on February 3, 1799, and raised seven children here. An 1807 receipt notes that John Albert paid his annual rent of 17 bushels and 46 pounds of wheat to the patroon. The front section of the house with its vine-draped porch was added after the property was deeded to John and Leah's son John I. Slingerland in 1842. John I. was elected to the New York Assembly (1843–1844 and 1860–1861) and the United States Congress (1847). He was known for his work for tenant rights, an early version of the Homestead Act, and his role in the beginnings of the Republican Party. John and Leah's other sons, William Henry and Albert I., are mentioned elsewhere in this book. John and Leah's descendants made a lasting impact on the hamlet, hence its name change from Normanskill to Slingerlands in 1870. (TOB.)

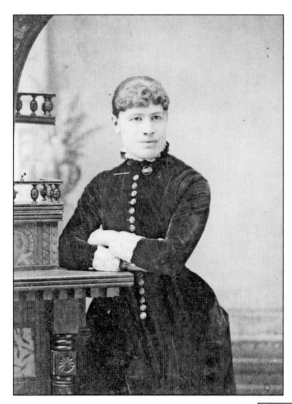

Lizzie Slingerland was the daughter of John and Leah Slingerland. She married William H. Coughtry and was a charter member of the Tawasentha Chapter of the Daughters of the American Revolution. She died May 19, 1918. (TOB.)

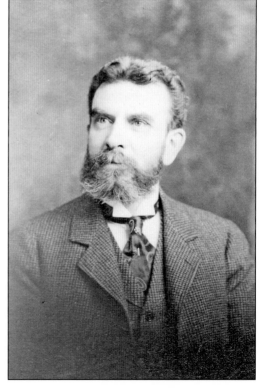

Jessie White Sprong bought the house at 698 Kenwood Avenue in 1886 from Albert I. Slingerland. J. White, as he was known, was an executive with the D&H Railway. In 1885, he was the assistant general passenger agent; by 1889, he was the comptroller and purchasing agent for the entire Northern Railroad Department. Sprong and his wife raised three children here—Harwood, Florence, and Elizabeth. After Elizabeth's death in 1960, the property was sold to the Claytons, who lived there for many years. (Courtesy of Sheri Sanduski.)

Shown about 1900, the Sprong house at 698 Kenwood Avenue was built by Albert I. Slingerland in 1874. It is one of five similar houses on New Scotland Road built by Slingerland that were later home to railroad executives. Note the potted palms in front of the house. For the colder months, these tropical plants were taken by railcar to Green Island, where there were greenhouses to keep them warm. (Courtesy of Sheri Sanduski.)

In this image taken from the rise of land to the rear of the Sprong house, the manicured grounds, tennis court, and pavilion are clearly shown. The carriage house burned in the 1970s. Today, this hill is heavily wooded. If one were to turn completely around from the spot where this photograph was taken, he would glimpse the Slingerlands Elementary School through the trees. (Courtesy of Sheri Sanduski.)

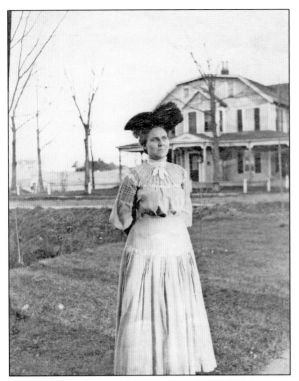

Lizzie Earl stands in front of the Conning home, which still stands on New Scotland Road today. In the background, to the left, one can glimpse the Frasier Home, built by Andrew Conning about 1850. His grandfather, also Andrew Conning, served in the Albany County Militia during the American Revolution under Captain Van Derheyden. (TOB.)

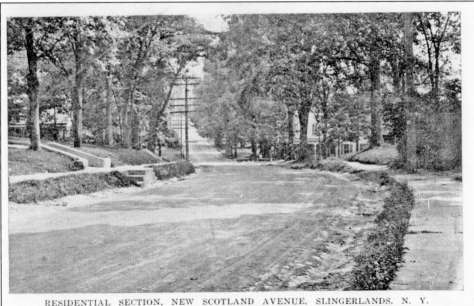

RESIDENTIAL SECTION, NEW SCOTLAND AVENUE, SLINGERLANDS, N. Y.

The view of New Scotland Road has changed very little from when this c. 1910 postcard was published. To the left is the walkway leading up to the Slingerlands Community United Methodist Church. Note the stepping or mounting block used to enter horse-drawn carriages or to mount riding horses. The Conning home (in the previous image) is located on the right of the curve. (Courtesy of Shirley Martin.)

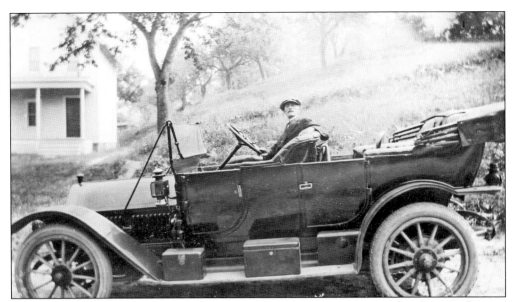

Andrew J. Earl of McCormack Road shows off his automobile. A note on this photograph states that his was one of the first cars in town. Bethlehem's Town Archive has a copy of his New York State chauffeur's license issued on February 1, 1915, when Earl was 50 years of age. It authorized him to operate gasoline motor vehicles. One wonders how many passengers he drove around Slingerlands. (TOB.)

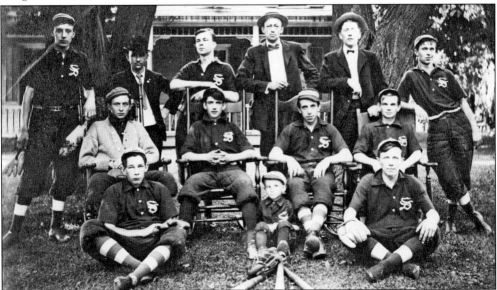

The Slingerland Village Wonders played as members of the Susquehanna League that formed around towns on the D&H Railway. The September 4, 1908, edition of the *Altamont Enterprise* notes that over 500 people watched the baseball game against the Altamont team. It was described as "A Snappy Game From Start to Finish." The ball field was on Kenwood Avenue near Union Avenue. Team members are, from left to right, (first row) Perry Pier, mascot Kenneth Boutelle, and Howard Sager; (second row) John Oliver, Artie Callan, Cartwright, and Ira Pier; (third row) Bert Sager, umpire Clarence Earl (in derby hat), Clarence Houck, "Bug" Whitman, George Dixon, and an unidentified player. (TOB.)

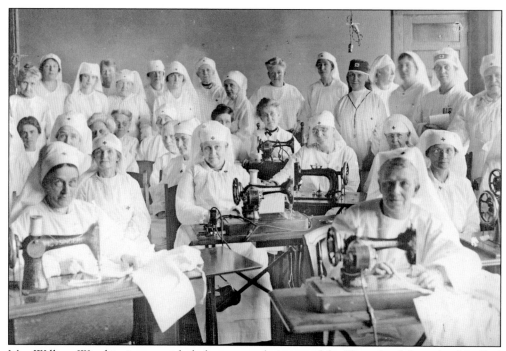

Mrs. William Winship, in rear with dark cap, was chairman of the Slingerlands branch of the Red Cross during World War I. Under her leadership, the women provided hospital supplies, sewed hospital shirts, and knitted up sweaters, socks, and scarves in support of the US military. (TOB.)

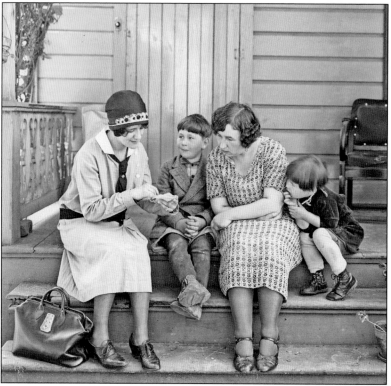

A school nurse interviews a mother and children in 1929. Part of the New York State Education Department's visual instruction series, this porch scene with its wooden steps and intricate railing is evocative of Slingerlands many Victoria-era homes. (Courtesy of the New York State Archives.)

Three

DELMAR

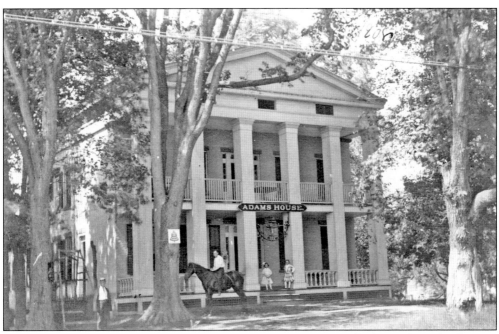

The Adams House Hotel was established on the Delaware Turnpike by Nathanial Adams in 1838. Adams, a well-known chef at the Marble Pillars Hotel in Albany, saw an opportunity in the rural area soon to be known as Adamsville. The Adams House quickly became a community gathering place, hosting socials and dances and becoming the unofficial political hangout. The building was purchased by the Delmar Fire Department in 1920 and served as Bethlehem's town hall from 1950 to 1980. (Courtesy of Janet Vine.)

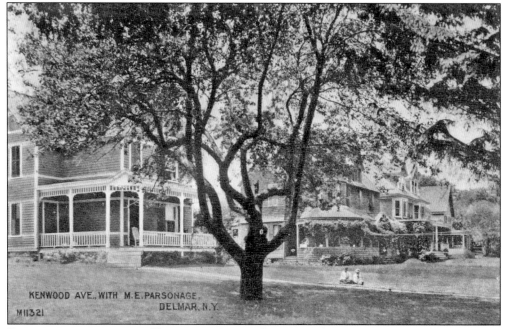

Presenting a pretty view of homes on Kenwood Avenue, this vintage postcard features the parsonage of the Methodist Episcopal church built in 1873. The home was demolished in 1962, when a new education wing was added to the church. (TOB.)

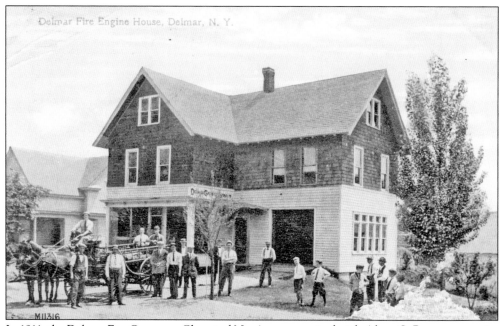

In 1911, the Delmar Fire Company Chemical No. 1 was organized with Alton C. Rowe as captain. While the fire company held its early meetings at the Adams House, this postcard indicates a different firehouse on Kenwood Avenue near the Four Corners. In 1920, the fire company purchased the Adams House, and by the late 1940s, the company was formally established as the Delmar Fire District. (TOB.)

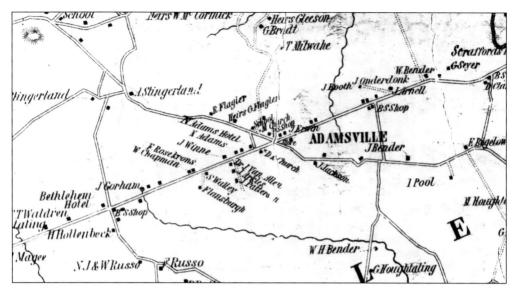

Adamsville is clearly noted on this 1851 map. Many of the locations on the map are represented herein with photographs, including the D.R. Church, M. Church, school, and Adams Hotel. Note the Bethlehem Hotel at the corner of Delaware Avenue and Cherry and Elm Avenues. (TOB.)

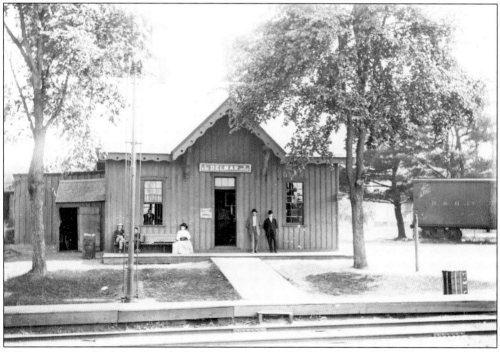

Folks are waiting for the train at the Delmar Station in 1907. Located on Adams Street, the Delmar Station was convenient for Adamsville residents to hop the train for business and shopping in Albany. The reason the D&H Railway chose the name *Delmar* for the station is unknown, but by the late 1880s, locals started referring to the area as Delmar instead of Adamsville. However, as late as 1893, a map still lists both names. By about 1900, the name *Adamsville* had been dropped completely. (TOB.)

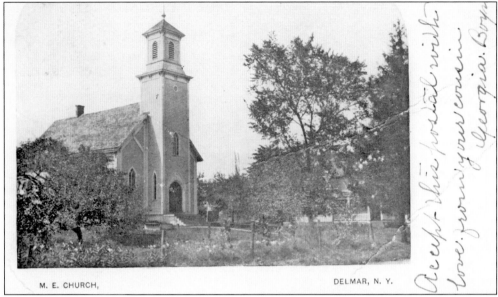

M. E. CHURCH, DELMAR, N. Y.

The first record of the First United Methodist Church of Delmar reads, "The Lord owned and blessed the labors of His servants in the conversion of fifty souls in the town of Bethlehem, 4 1/2 miles from Albany near the Delaware Turnpike, during 1832–33." The church erected its first building in 1833 on the north side of Kenwood Avenue. The following year, the church incorporated as the Second Methodist Episcopal Church in Adamsville, New York. Above is a postcard from the early 20th century of the third church building constructed in 1873 at 428 Kenwood Avenue on land donated by Nathaniel Adams. In 1968, the church became the First United Methodist Church of Delmar. Below, a postcard mailed in 1908 shows the interior of the church, apparently decorated for Christmas. Since electric lights were not installed in the church and parsonage until 1911, the chandelier in this image was probably lit with gas lamps. (Above, courtesy of Janet Vine; below, TOB.)

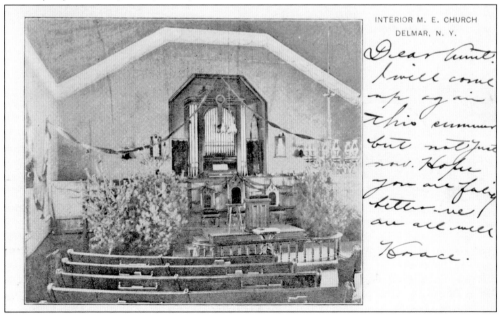

INTERIOR M. E. CHURCH
DELMAR, N. Y.

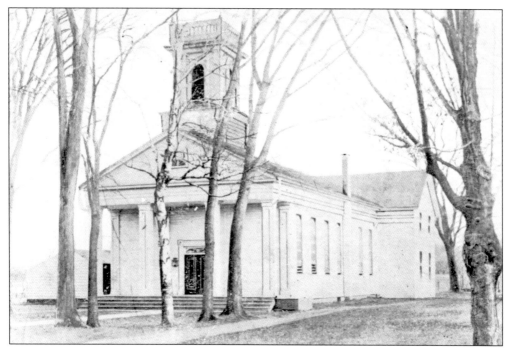

The east branch of the Unionville Reformed Church built this church on Delaware Avenue in 1841 on land donated by Nathaniel Adams. The Delmar church separated from Unionville in 1848, becoming the Second Reformed Protestant Dutch Church of Bethlehem. In this pre-1927 photograph, one can glimpse the old carriage shed to the left of the church. In 1912, the congregation changed its name to Delmar Reformed Church. (TOB.)

This lovely old home on Delaware Avenue at the corner of Adams Street no longer stands. This photograph was taken November 6, 1949, and shows the Delmar Reformed Church in the background. At one time, George C. Adams, son of Nathaniel Adams, lived here with his wife, Mary. George served as Bethlehem's town supervisor from 1867 to 1870. (BHA.)

Looking west from Grove Street along Delaware Avenue about 1910, this view shows a very different Four Corners. The Delmar Hotel is on the left; on the right is what looks to be a general store in the frame building, which still stands today. (TOB.)

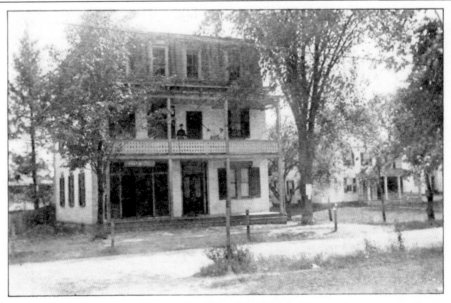

POST OFFICE, DELMAR, N. Y.

With its distinctive mansard roof, this building is a Four Corners landmark. Built about 1905 by Esley Winne, it is shown here in its days as the Delmar Post Office. Many Delmar old-timers remember when Earl C. Adams had his hardware store here. Today, the structure houses I Love Books. Glimpsed through the trees to the right is the parsonage of the Delmar Reformed Church. It was built in 1851 and removed in 1935 to make way for the current parsonage. (TOB.)

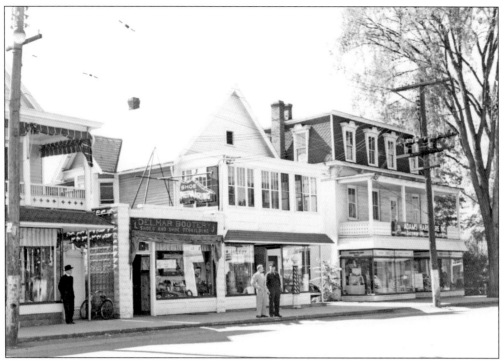

A stretch of Delaware Avenue is seen on September 18, 1950, in these two photographs. Above are, from left to right, the Delmar Bootery, a barbershop, and the Adams Hardware Store. The buildings remain today, slightly modified, with new business. Below, a man is walking under the trees along Kenwood Avenue. The Getty gas station at this intersection was demolished in 1995. A minipark with an old-fashioned clock occupies this point of land today. (Both, BHA.)

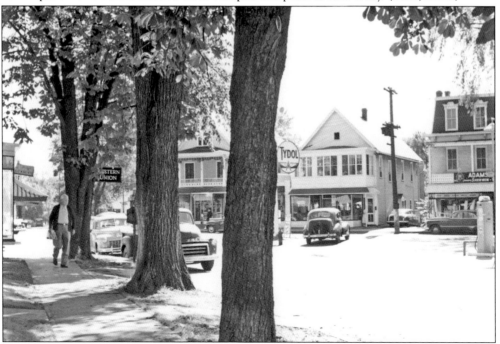

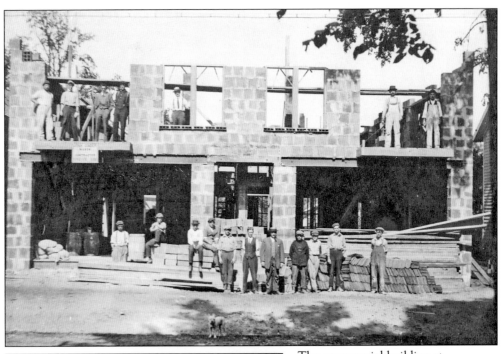

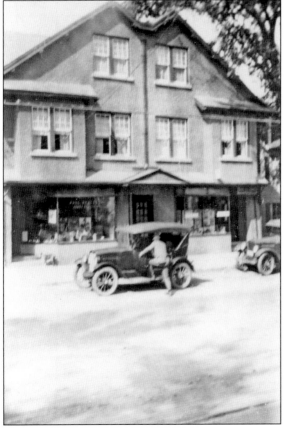

The commercial building at 250 Delaware Avenue is under construction in the c. 1925 photograph above. For many years, Lucille Williams had her Thistle Shop in the left storefront with Harry Brown's jewelry store inside. The right side was occupied by a pharmacy. At left is the completed building, which still stands today. The building glimpsed to the right, which is at the corner of Grove Street, was the Three Elms Hotel and Bar, which burned down in the late 1940s. (Both, TOB.)

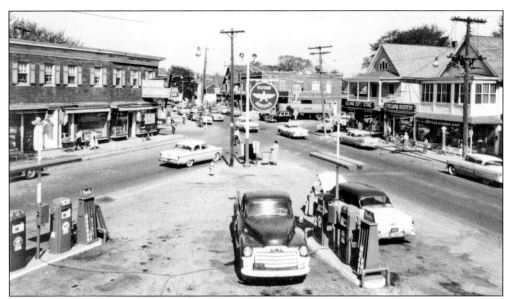

The Four Corners bustle in this 1957 view looking east. Through the years, the intersection of Delaware Avenue and Kenwood Avenue grew from a country crossroads to become the heart of the hamlet of Delmar. As early as the 1920s, the Delmar Four Corners was a known location instantly recognizable in local advertising. (TOB.)

The Paddock Block was built about 1920 by Howard P. Paddock, a prominent real estate broker and developer in the Delmar and Elsmere area. Paddock was also concerned with the orderly development of town. He served as chairman of the town's planning board from its inception in 1944 until his death in 1969. Originally charged with "preserving the attractiveness of our town," the board today is an active part of reviewing and approving new developments. (TOB.)

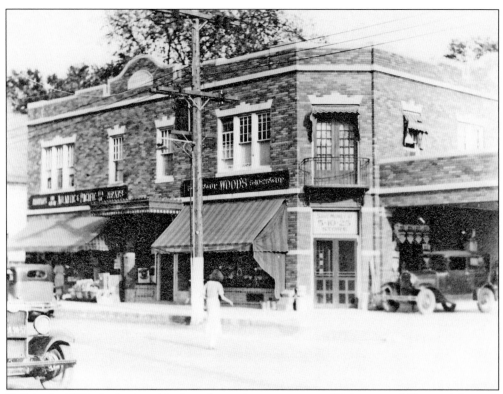

Built in the 1920s, the business block on the southeastern corner of Delaware and Kenwood Avenues has hosted many enterprises over the years, including Woods 5-10-25 Store and Carroll's Pharmacy. Arthur Starman ran Carroll's from the late 1930s until about 1960, when he sold it to Al Warner. The building was demolished in 1974 to make way for the National Savings Bank. (TOB.)

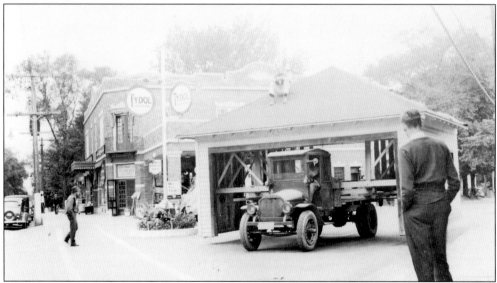

An unidentified thrifty Delmar resident moves what looks to be a garage through the Four Corners in the 1940s. In the background are the Tydol gas station and the business block seen above. Note the hitchhiker on the roof. (TOB.)

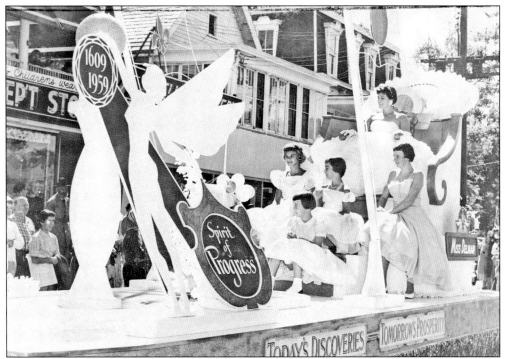

Miss Delmar, Jane S. Wilson, rides atop the Spirit of Progress float during the Parade of History on September 12, 1959, with her court seated before her. In front is Judy McDowell. Behind her are, from left to right, Barbara Schreck, Susan Dunham, and Patricia Dunham. In 1959, New York State marked the 350th anniversary of the historic journeys of Henry Hudson and Samuel de Champlain with a Year of History. Bethlehem's committee, led by town historian Ruth Dickinson, urged participation in local concerts and fairs, an essay contest, historical exhibits, and a regatta at the Cedar Hill Yacht Club. (TOB.)

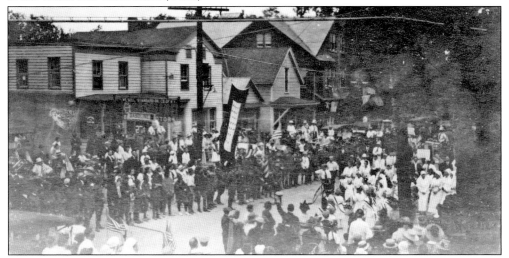

Bethlehem loves a parade. Spectators line Delaware Avenue at the Four Corners in anticipation of a Fourth of July parade in the early 1900s. Today, Bethlehem residents keep the tradition of the parade alive on Memorial Day. In recent years, a holiday parade has taken place in early December. (TOB.)

Clarence and Grace Blanchard pose in front of their impressive two-family home. Family history relates that the house was built for Louise Haswell Adams (daughter-in-law of hamlet founder Nathaniel Adams and his wife, Rhogenia) for her daughters Jessie Adams Dyer and Grace Adams Blanchard. Apparently, the two sisters lived side by side for years. Grace Adams married Clarence Blanchard Sr. One of their sons was Nathaniel, who was memorialized with the naming of the Nathanial Adams Blanchard Post of the American Legion, established in 1930. Nathaniel was killed in action on November 9, 1918, while serving with the 307th Infantry, 77th Division near the close of World War I. Below, on May 23, 1937, Clarence Blanchard Sr. takes his horse King out for a trot. (Both, TOB.)

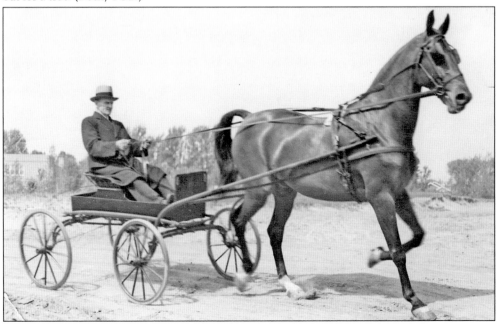

Jessie Adams, pictured, married Zeb A. Dyer in 1889. Dyer was a prominent local attorney and was elected Albany County district attorney in 1898. He suffered an untimely death at age 44 in 1904. A handwritten note on this picture says, "Aunt J. looked lovely in her serge gown. Wish you could have seen her. It will be too warm to wear when you get home." (TOB.)

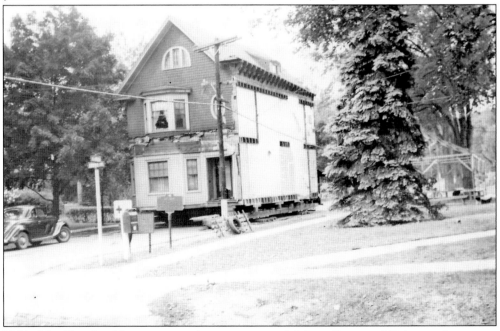

Half of the Blanchard house crosses the intersection of Adams Street and Delaware Avenue on the way to its new location at 403 Delaware Avenue. The home was moved from the west side of the Four Corners in 1941 to make way for development. (TOB.)

On June 3, 1945, a woman appears to wait for the bus at Delaware and Borthwick Avenues. The distinctive building on the right at one time housed a hotel for travelers along the Delaware Turnpike. Over the years, a grocery and radio repair store have been housed here. In 1970, the Bethlehem Public Library was built at the location of the house. (BHA.)

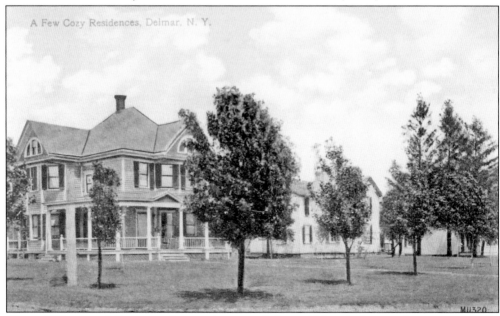

This c. 1910 postcard illustrates a few cozy homes in Delmar. Although the exact location cannot be determined, it was probably taken along Delaware or Kenwood Avenues. The card shows the large suburban homes that were found at the turn of the 20th century. (Courtesy of Shirley Martin.)

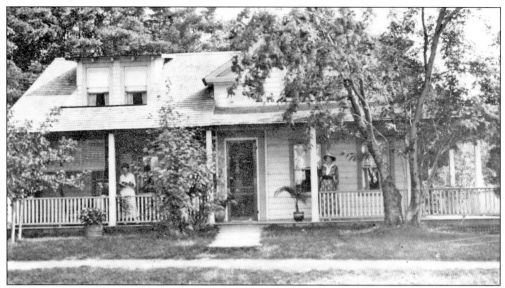

Two elegant women stand on the wide porches of the Van Allen residence at 300 Kenwood Avenue. Like many old homes, it was demolished in the 1960s to make way for an apartment building. Kenwood Avenue is so named because a person could follow it to the Kenwood section of Bethlehem near the mouth of the Normanskill. (TOB.)

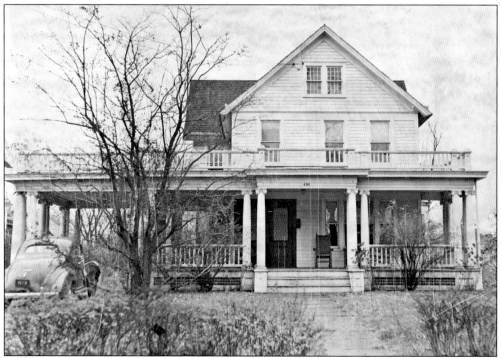

Many of Delmar's stately homes have been repurposed over the years. This house at 404 Delaware Avenue became the new location of the Veterans of Foreign Wars Bethlehem Memorial Post 3185 shortly after its organization in 1946. James Austin was its first president. Since the days after the Spanish-American War, the VFW has been supporting and advocating for US veterans. (TOB.)

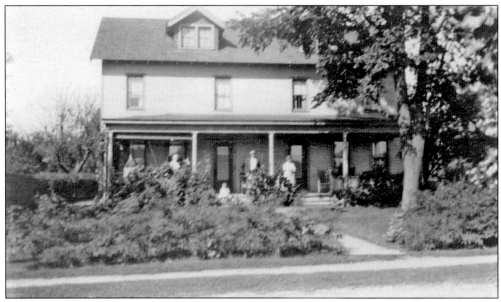

Henry Cox Baxter (1833–1914) was born in England. He came with his family to the United States and settled in Knox, New York. Sometime after his marriage to Elizabeth Van Auken of Knox, Baxter moved to this home on Borthwick Avenue (corner of Stratton Place) and opened a blacksmith shop there. The Baxters raised six children in this house. One son, David, followed in his father's footsteps and opened his own blacksmith shop in Normansville. (Courtesy of Barbara Castle.)

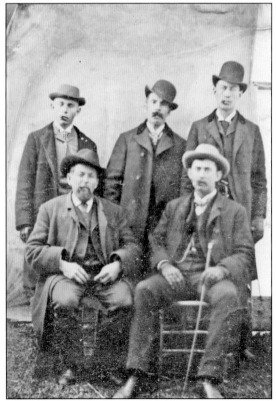

With lips clamped around their cigars, Henry Cox Baxter (with beard) and his sons pose in this tintype taken about 1900. Seated next to Henry in the front is son Horace (b. 1877). Standing in back are, from left to right, David (b. 1869) and twins Fred and George (b. 1874). (Courtesy of Barbara Castle.)

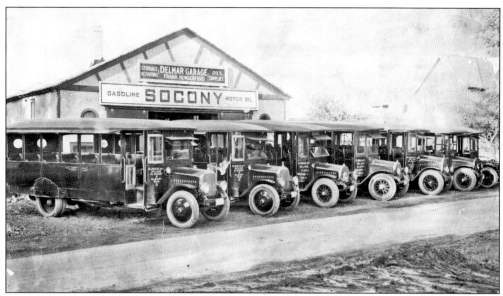

Frank Hungerford established the Tri-Village Bus Service about 1915. For 5¢, riders could travel between Albany, Elsmere, Delmar, and Slingerlands via Delaware Avenue. Hungerford worked to extend his line to Slingerlands and Whitehall via New Scotland Road and later to New Scotland, New Salem, Voorheesville, and Altamont. Readers of the July 5, 1928, edition of the *Altamont Enterprise* noted the following: "On July 2nd, the Hungerford bus line from New Salem to Albany was inaugurated. Now, all you fellows who hollered loudest for that bus and the imperative need of it, let's see you leave the old car in the barn and patronize the bus." In 1943, Hungerford sold his business to the United Traction Company, forerunner of the modern CDTA. Below, a crowd gathers to inspect the destruction at Frank Hungerford's Delmar Garage after an intense fire in April 1931. Twelve buses were either destroyed or damaged at the garage located on Kenwood Avenue. Losses were estimated in excess of $50,000. (Both, TOB.)

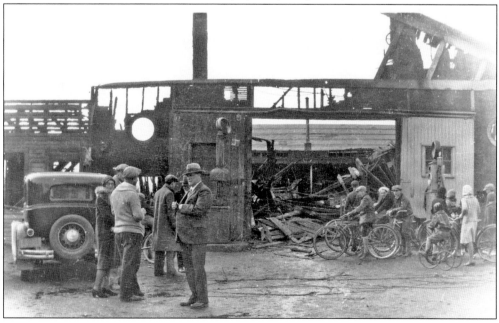

SCHOOLHOUSE. DELMAR, N. Y.

The intersection of Kenwood Avenue and Adams Street hosted a schoolhouse at least as early as 1850. Above, in a c. 1900 postcard, is the original District No. 10 one-room school. Note the rural roadway and abundant trees. In 1909, the one-room schoolhouse was replaced by the commodious building shown below in a c. 1920 postcard. It remained a school until the new Delmar School was built in 1925. In 1929, the building was purchased by the Bethlehem Masonic Lodge, which makes its home there today. Even the neighboring house is still standing. (Both, TOB.)

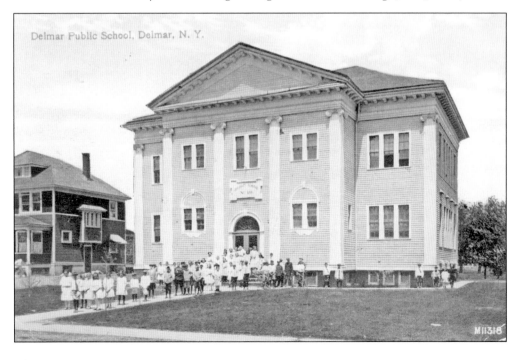

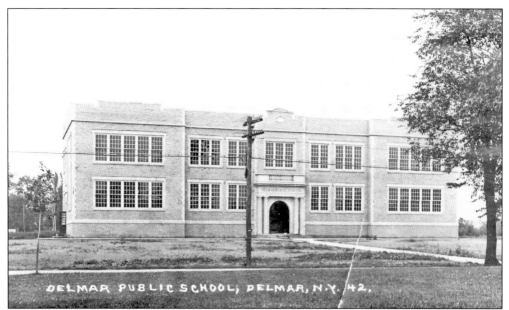

The Delmar Public School is shown shortly after its completion in 1925. The building on Delaware Avenue replaced the earlier schoolhouse that still stands at the corner of Kenwood Avenue and Adams Street. When the last students transferred out in the 1970s, the Town of Bethlehem entered into negotiations with the school district to purchase the building at fair market value. After renovations, Bethlehem Town Hall opened here in 1980. (TOB.)

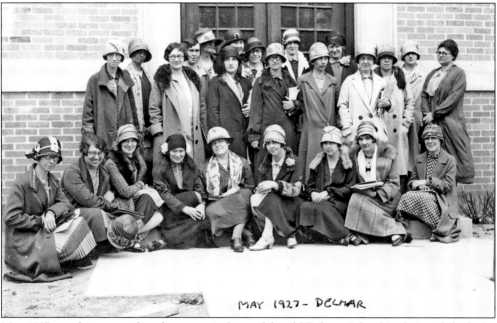

May 1927 saw this group of teachers pose in front of the old Delmar School in their stylish cloche hats. Cloche hats were popular in the 1920s. *Cloche* means "bell" in French, reflecting the shape of these embellished felt hats. Every hat in the picture has its own unique ribbons and bows, flowers, and ruffles. Lucille Hannay (Mrs. Harry Briggs), who was a teacher here from 1927 to 1929, donated the picture. (TOB.)

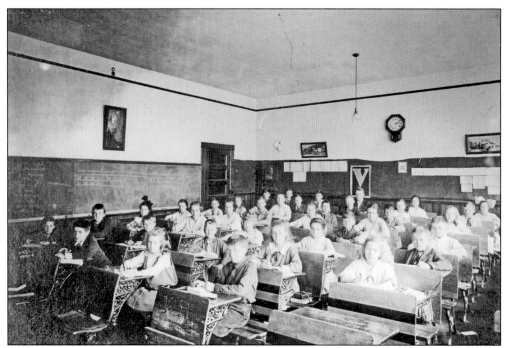

With books and pencils at the ready, schoolchildren sit at their desks at the Delmar School on Kenwood Avenue in 1921. A penmanship lesson is on the chalkboard. One wonders what the large V on the wall symbolizes. (TOB.)

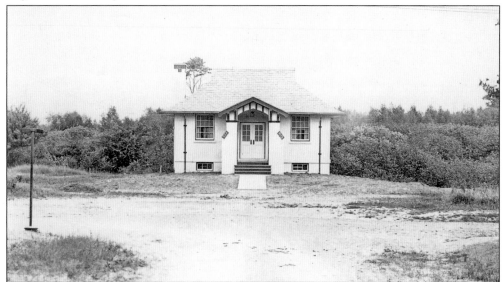

In a spirit of promoting public literacy, the Delmar Progress Club established the Delmar Free Library Association in 1913. Originally located in one room of the Delmar schoolhouse, the library moved into its first building (shown here), constructed on land from the estate of George C. Adams. In 1931, the library became the responsibility of the local school district. At the time, it had about 2,750 books. In 1972, the Bethlehem Public Library moved to its present location on Delaware Avenue. Today, the building pictured, with 1954 additions, stands at Adams Place and Hawthorn Avenue surrounded by homes. (TOB.)

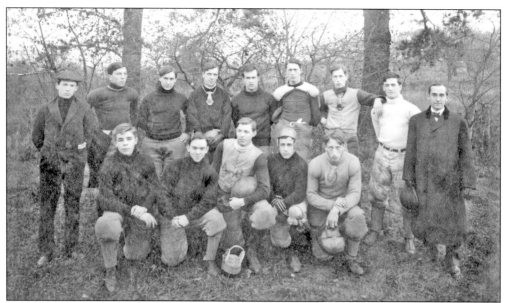

The Delmar football team is shown here in 1905. The photograph only lists last names. From left to right are (kneeling) Boutelle, Warrington, Smith, team captain Kirkland, and Van Wie; (standing) manager E. Jones, McKown, McCormack, Cranney, Palmer, Creble, Sprong, Mochrie, and assistant manager G. Sprong. The team was well equipped. Several of the players sport a football nose guard that was patented in 1891 as well as padded pants and helmets. The December 1, 1905, issue of the *Altamont Enterprise* reports on a game between Delmar and the high school at Cobleskill. Delmar won 12-0, with Mochrie and Van Wie being key players. "The Delmars were a gentlemanly lot of players and played a clean game." (TOB.)

Captain William's home still stands at 411 Kenwood Avenue. By 1940, Sporthaven Alleys and Rink had replaced the homes in the background. In those early years, Sporthaven competed with the Delmar Bowling Alley on nearby Adams Street. By 1944, only Sporthaven was left, providing bowling and fun until it closed in 1982. (BHA.)

In 1938, the lot across Darroch Road from Max Simon's house featured extensive gardens. Delmar's rural character is obvious. Today, the Darroch Road area is thoroughly built-up with houses. The home shown here is still a stately presence. (TOB.)

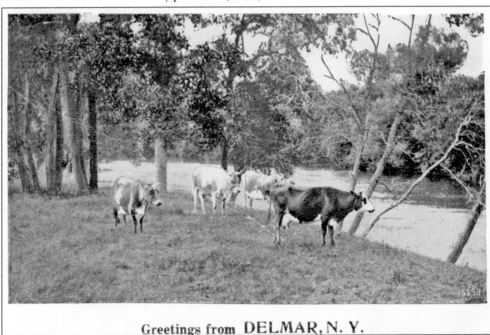

Greetings from DELMAR, N. Y.

Dairy cows enjoy the grass by the side of a large creek in the early 1900s. While the postcard offers greetings from Delmar, what is today known as Delmar does not boast a creek of this size. The postcard likely shows the Normanskill, which swings around north of Delmar from Normansville, which is to the east. From its earliest days, Bethlehem was primarily an agricultural community, with dairy playing a significant role. Morse's 1797 *American Gazette* reports that Bethlehem is "very fruitful in pastures, and has large quantities of excellent butter." (TOB.)

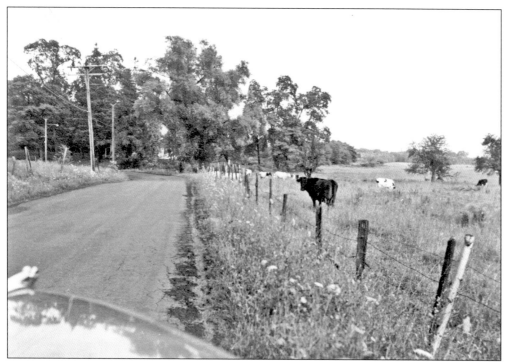

On July 23, 1953, a cow observes a car passing along Cherry Avenue. In the years since, single-family homes have filled in on both sides of the road. (BHA.)

Since 1932, Verstandig's Florist has been a family-owned business. The barn on Delaware Avenue, shown here on June 20, 1954, was renovated and expanded to accommodate the growing floral and gift store. Old-timers will remember the barn painted white with "Verstandig's" in large script letters across the peak. Change came once again in 2011, as the land was sold and the greenhouse and retail operations consolidated at the Creble Road location. (BHA.)

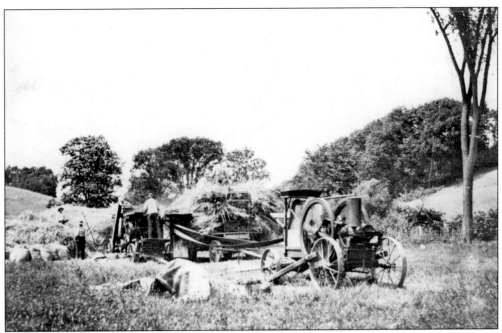

In 1909, workers on the Wright farm thresh grain—most likely oats, wheat, or rye—in a typical Bethlehem scene. The engine on the right runs the threshing machine, which removes the grain from the straw. On the left are the full bags of grain. Wright's farm was located at the end of North Street. (BHA.)

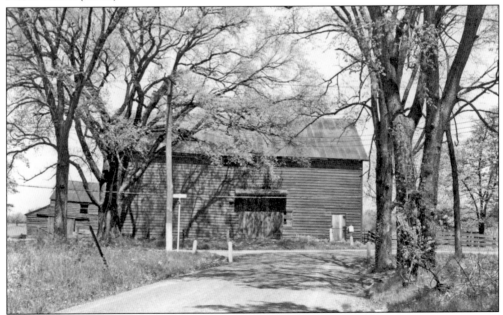

Today, the intersection of Van Dyke Road and Delaware Avenue bustles with traffic around Bethlehem Central High School, Eagle Elementary, and the district's bus garage. In this photograph from May 10, 1953, just before the high school was constructed the following year, the area retains its rural atmosphere. The Morehouse barn was later demolished, and Longmeadow Drive took its place. (BHA.)

Houcks Corners is on the outskirts of Delmar at the intersection of Feura Bush Road and Elm Avenue. The District No. 8 school was located near here as well as the Haswell-Houck Tavern, pictured above on June 22, 1943. Built about 1845, the tavern served stagecoaches crossing Albany County as a useful resting stop and a place to exchange mail. The bicyclist rests by a signpost that indicates seven miles to Albany and 154 to New York. Just down Feura Bush Road is the Elm Garage, seen below on October 11, 1958. As the sign says, one could get "expert body fender work" done or purchase Atlantic gasoline products. Atlantic traces its history back to 1866 and in 1966 merged with Richfield Oil to form ARCO. (Both, BHA.)

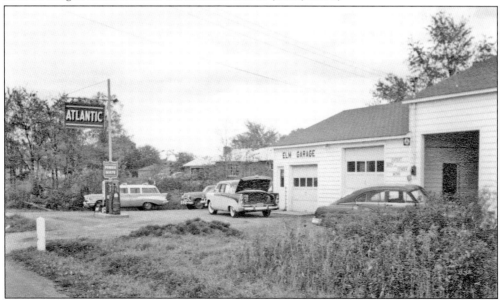

Located on Feura Bush Road (Route 32), Sunnybrook Farm was the center of a cattle-holding farm run by members of the Corning family. In 1943, Charles Waldenmaier and his wife, Virginia Elmendorf, purchased the property for general farming and improved the land with extensive apple orchards. Buried in the family plot on a knoll behind the house are Frederick Britt and his wife, Helena Burhans. Britt had his sons-in-law Frederick and John Luke build the house about 1801 after his service with the 1st Regiment, Ulster County, New York militia during the American Revolution. He died in September 1811 at age 66. Helen followed him in October 1838. Their daughter Leah married John Albert Slingerland. Above is the farm in 1934; below is a view taken in June 1944. A cyclist can be seen riding on what today is a busy highway. (Above TOB; below, BHA.)

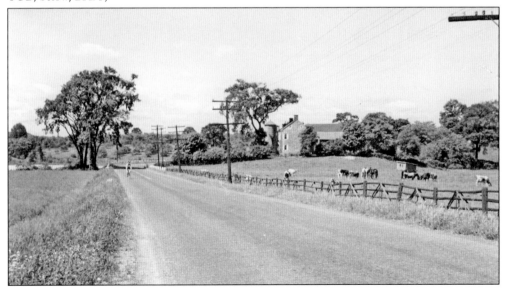

Mr._____ and Lady,

The pleasure of your company is respectfully solicited to attend a

❋ MAY SOCIAL ❋

TO BE GIVEN AT THE

BRICK HOTEL, SNYDER HILL,

On Tuesday Evening, May 22d, 1883.

Good Music will be in Attendance.

TICKETS, INCLUDING SUPPER, $1.50.

COMMITTEE OF ARRANGEMENTS:

WM. SNYDER, CHAS. LONG, JOHN HENDRICKSON, JAMES SHANKS.

D. Handler, Printer. 288 S. Pearl St., Albany.

During the 1880s and 1890s and into the early 20th century, Snyder Hill was a well-known hamlet. Today, the area is close to Feura Bush and the Delmar zip code. The Brick Hotel at Snyder Hill, shown below in a vintage postcard, bustled with activity in its heyday. Today, the remains of the hotel can be seen on Henry Drive, just off Feura Bush Road (Route 32). Besides providing meals and lodging to travelers, the Brick Hotel sponsored events like the May social scheduled for May 22, 1883. The invitation above promises "Good Music will be in Attendance." The Brick Hotel was also one of several locations around town where Bethlehem's collector of taxes would receive tax payments. (Both, courtesy of Shirley Martin.)

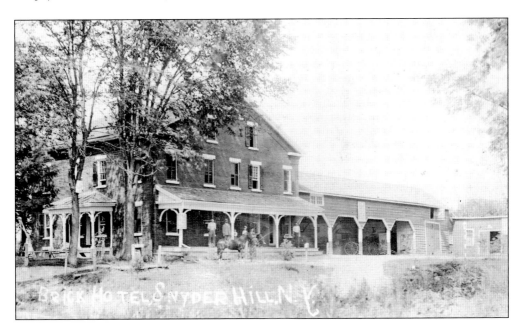

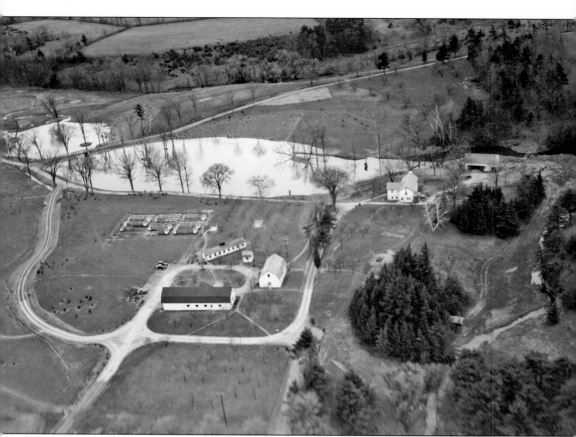

Shown here in an aerial view from 1938, the Delmar Experimental Game farm was formed in 1933 for the propagation and management of upland game birds and waterfowl. The ponds were created by the Civilian Conservation Corps, Camp S-72, by damming the Vlomankill. To the left is Beaver Pond, and to the right is Heron Pond. In 1941, a wildlife research center was added; in 1948, an exhibition of caged wildlife opened that became known as the Delmar Zoo. After it closed in 1970, concerned citizens convinced New York State to create the Five Rivers Environmental Education Center at the site. The name derives from the five waterways that have a watershed in the center's service area: the Hudson, Mohawk, Hoosic, and Sacandaga Rivers and Schoharie Creek. (Courtesy of the New York State Archives.)

Four

ELSMERE

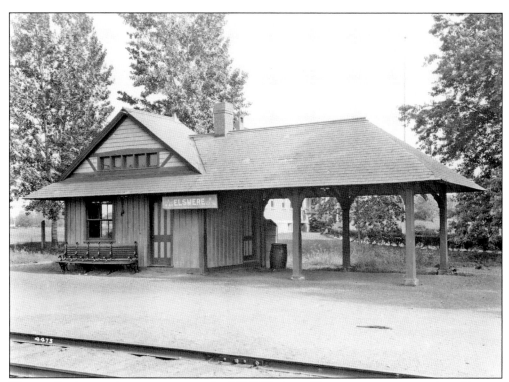

Elsmere Station awaits passengers on the D&H Railway. The station was near where Elsmere Avenue crosses the tracks. F.W. Beers's 1891 map from his *Atlas of the Hudson River Valley* lists this station as East Delmar. By 1894, this area was becoming known as Elsmere. One theory as to the source of the name notes that Mrs. Humphrey Ward's *Robert Elsmere* was a blockbuster novel published in 1888. In 1912, residents petitioned to the Public Service Commission for freight and baggage service at Elsmere. The commission found Elsmere to be a collection of residences without business of any kind, and the petition was denied. (TOB.)

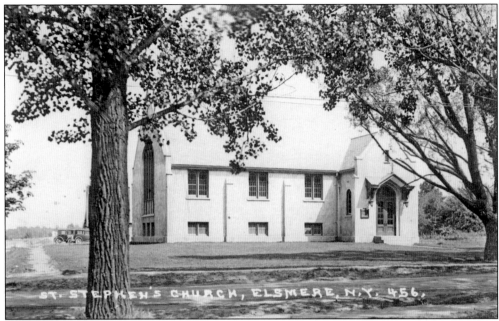

In 1908, a small group of like-minded men worked to establish an Episcopal church in Elsmere. For many years, members of St. Stephen's Mission worshipped in a former blacksmith shop on Delaware Avenue. In 1925, the congregation, now known as St. Stephen's Episcopal Church, began construction of its Elsmere Avenue building, shown here in a 1925 postcard. (Courtesy of Janet Vine.)

The Elsmere Fire Company, organized in 1922, built a fire station in 1929 on Poplar Drive. Shown here on June 28, 1953, it was named the Adams Memorial Station in honor of William C. "Bill" Adams, who lost his life in World War II. Today, the station has been considerably improved and modified to meet the needs of the modern fire company. (BHA.)

Elsmere Avenue crosses the D&H tracks in these c. 1930 photographs. The elimination of this grade crossing was first proposed to the State Department of Public Works in 1929 at a cost of $68,300. The underpass, and similar ones at Delaware Avenue and New Scotland Road, was eventually constructed. The above image looks north towards Delaware Avenue. Below looks south with St. Stephen's Episcopal Church and a bit of the roof of the passenger station on the left. The building with a grocery store and post office on the right is still standing and can be reached by a flight of stairs up from Elsmere Avenue. (Both, courtesy of Randy Bushart.)

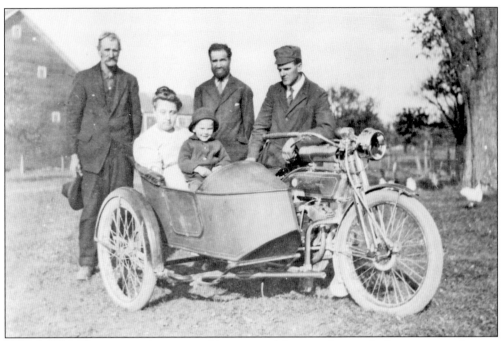

Prior to 1900, Elsmere was characterized by scattered farms with more built-up areas to the east at Normansville and the west at Delmar. In the photograph below, William Salisbury's farm on today's Salisbury Road is seen about 1915. Members of the Salisbury family owned a large number of acres here as early as 1851. Above, also in 1915, Howard F. Salisbury, right, has ridden his motorcycle to the Salisbury farm. William Salisbury, center, looks on as his wife, Emma, and son Howard try out the sidecar. The man at left is unidentified. Today, instead of being a long farm road leading into the countryside, Salisbury Road goes past lovely homes from the 1920s, 1930s, and 1940s. At the end of the road is the Normanside Country Club, proposed in 1926 by Elsmere booster and attorney William A. Glenn. Its first nine holes opened in 1928. (Both, TOB.)

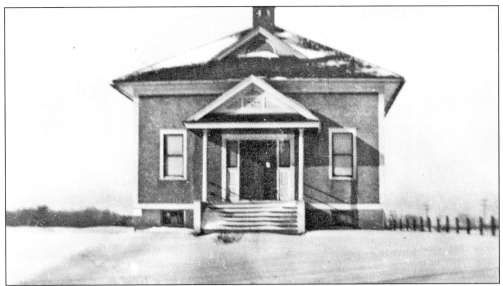

Elsmere's one-room schoolhouse, District No. 15, was created when the Normansville School became too crowded. It was built in 1911 on Poplar Drive near the railroad station. The school was enlarged in 1915. The current Elsmere School building on Delaware Avenue was constructed in 1926. (TOB.)

In one of the last classes to graduate from the schoolhouse on Poplar Drive, these eighth graders pose for a group portrait in 1925. In this picture are, from left to right, Kenneth McNary, Elmer Yelton, unidentified boy in back, teacher Etta Cass, Naomi Albreck, Claude White, Helen Orvis, and Ava Stover. (TOB.)

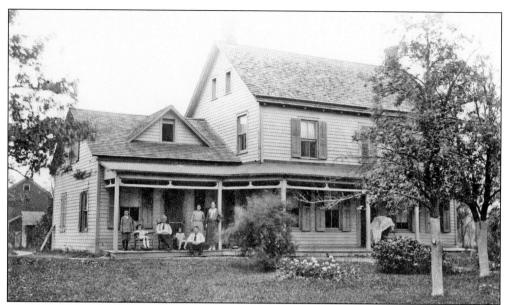

The David Clark homestead used to stand on Delaware Avenue near the corner of Mason Drive. It is shown here in 1925, when it was owned by the Welter family. A glimpse of the farm's large barn is visible to the left. On the porch are, from left to right, Leonard Welter Jr., Jeannette Welter, Jan Arend Sr., Caroline Welter, and Jan Arend Jr. The two women standing on the right are Mrs. Welter and Mrs. Arend. It is not clear which woman is which on the original label. In the baby carriage under the netting farther down the porch is Lawrence F. Welter. (TOB.)

Walter Wright, eldest son of Francis Wright, made daily deliveries of milk from his wagon in 1906. Note the large can from which the milk was ladled into the customer's pail or container. The photograph was taken on the Albany and Delaware Turnpike, now Delaware Avenue, in Elsmere near the Booth Farm. (BHA.)

Oakwood Road was a woodsy, rough, rutted road in the early 1900s as it passed over an unnamed creek, a tributary of the Normanskill. When the Delmar Bypass was constructed in 1964, this section of Oakwood was closed and rerouted sharply west to intersect with Bender Road. (TOB.)

Simply identified as "Scrafford's house in Elsmere," this sturdy farmhouse and its outbuildings are an example of Bethlehem's agricultural roots. Early maps show a Scrafford Hotel near where Mason Road intersects Delaware Avenue as well as a blacksmith shop. Edgar Scrafford served as highway superintendent from 1916 to 1922. From the town's earliest days, Bethlehem residents were concerned about the quality of their roads. At the first town meeting in 1794, three highway commissioners were appointed as well as 19 overseers. By 1871, fifty-five overseers were appointed. By Scrafford's term in 1916, this unwieldy system had been replaced by a single elected superintendent. (TOB.)

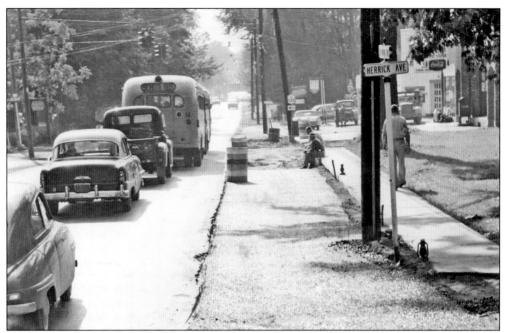

Since its days as the Albany and Delaware Turnpike, charted in 1804, Delaware Avenue has undergone many changes. Here, near Groesbeck Place and Herrick Avenue in 1958, the road is being widened. Soon, its leafy canopy will give way to four lanes of traffic, strip malls, and shopping plazas. (TOB.)

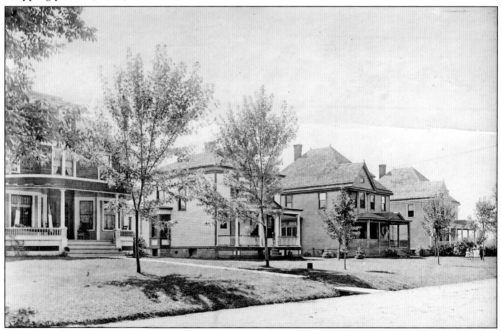

These stately residences line the south side of Delaware Avenue between Booth Road and Elsmere Avenue about 1908. From left to right, they are the homes of William Glenn, James J. Rodgers, Frank Knight, and Capt. William Wheelock. Several were moved to Booth Road to make way for modern stores and still stand today. (TOB.)

Automobiles travel along Delaware Avenue toward Elsmere on September 23, 1949. Old Delaware Avenue can be seen branching off to the right in the distance from the current location of Jim's Tastee-Freez. Tastee-Freez soft-serve ice cream stands started popping up across America in the 1950s. (BHA.)

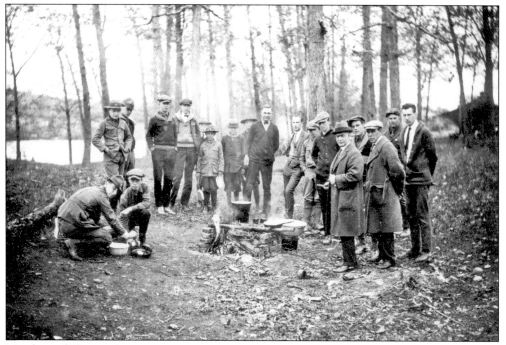

Members of Elsmere Boy Scout Troop No. 1 pose around the campfire in 1924 at Camp Hawley. Leonard Welter, scoutmaster and photographer, notes that they were the champions of the Albany Council for two years. His son Leonard Welter Jr. is in the photograph. (TOB.)

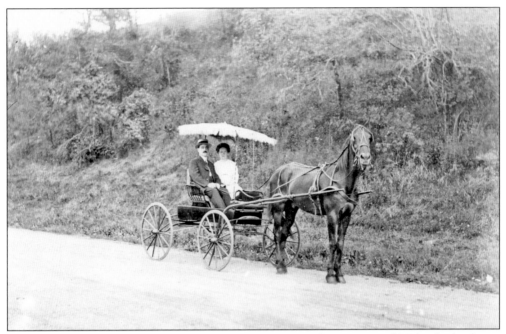

After arriving in the United States in 1906 and coming to Albany, Leonard Welter built a home on Euclid Avenue. He was an avid photographer of local scenes. "Sunday Go Meeting" was what he called this one of Mr. & Mrs. Alfred Eames and their horse and buggy. It dates from about 1910. (TOB.)

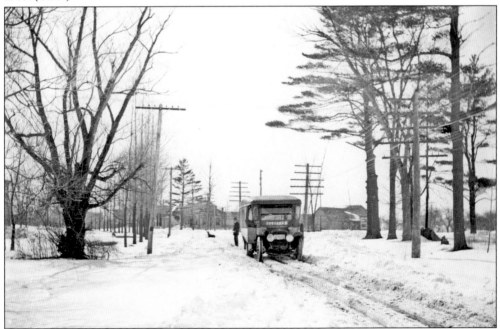

Photographer Leonard Welter called this image "Coming Through Snow, Elsmere." It was taken in 1918 on Delaware Avenue near Euclid Avenue. In the background, behind the Suburban bus, is a farm with a large barn. While the area still retains its rural character, electric light poles give evidence that change and development have arrived. (TOB.)

Five

NORMANSVILLE AND KENWOOD

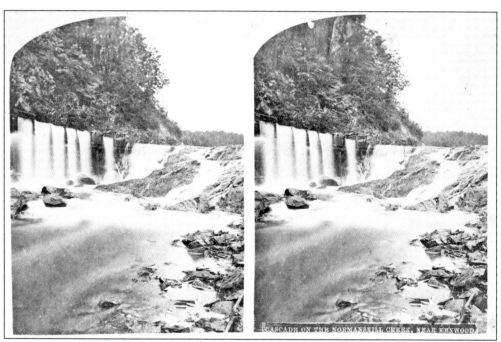

CASCADE ON THE NORMANSKILL CREEK, NEAR KENWOOD.

The Normanskill connects the hamlets of Normansville and Kenwood at the northern boundary of Bethlehem. Petanock, Secktanock, and Tawasentha are early Indian names of the creek shown in this stereoscopic view. The Vale of Tawasentha with its "green and silent valley" finds its way into Longfellow's *Song of Hiawatha*. Normanskill (*Noormanskill*) means Norwegian's creek in Dutch; Albert Andriessen Bradt was the Norwegian for whom the creek is named. Bradt arrived in April 1637 and made his living running a sawmill, farming tobacco, and in the beaver fur trade. His daughter Engeltie married Teunis Slingerland, who also farmed along the Normanskill. (TOB.)

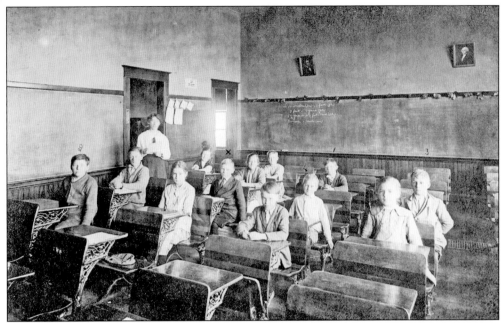

Pupils from Normansville District School No. 11 are admonished to "Do Right" (sign between the doorways) under the watchful eyes of Abraham Lincoln, George Washington, and their teacher. The X marks Malcolm Baxter. Numbers 1 and 2 are siblings Howard and Ray Harbeck; 3 and 4 are Fred and Quentin Seyboth. The photograph was taken about 1918. (Courtesy of Barbara Castle.)

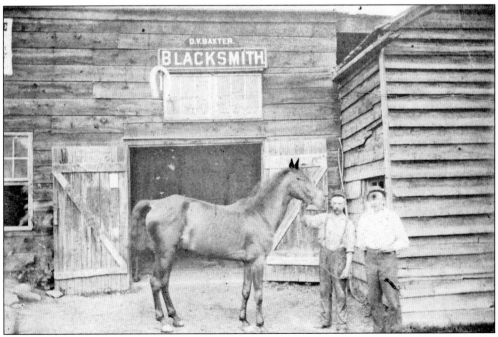

David Van Auken Baxter (1869–1946) holds the head of a horse in front of his Normansville blacksmith shop. Barbara Castle remembers coloring in the horse's ears on this c. 1909 photograph of her grandfather. (Courtesy of Barbara Castle.)

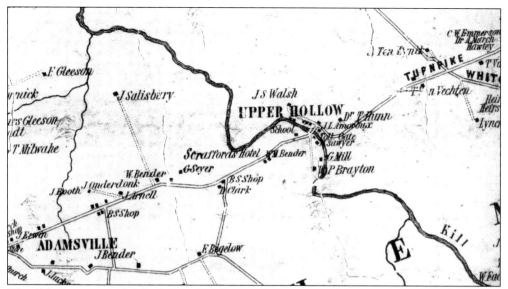

The 1851 Pease map clearly shows Upper Hollow. Note the schoolhouse and mill. Also clearly identified is Scrafford's Hotel, noted in the Elsmere chapter. (TOB.)

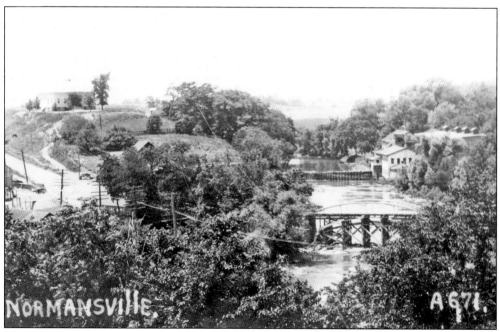

The Albany and Delaware Turnpike Company, chartered in 1805, built a wooden bridge over the Normanskill. It is reported to have been carried away in the spring floods of 1868. By this time, the turnpike company had abandoned the road, and the Town of Bethlehem had built a new, two-truss iron bridge. Here, the iron bridge is being replaced about 1900. Note also the Normansville School on the hill to the right and Pappalau's icehouse and dam on the left. (TOB.)

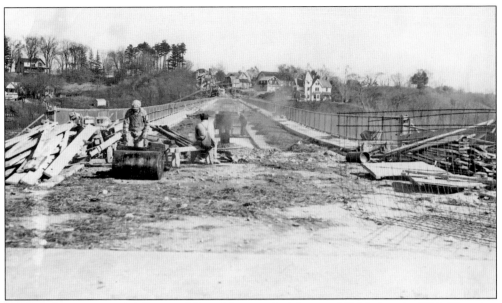

Workers for contractor J.J. Finn and Sons labor on the Normanskill Viaduct in 1928. The view looks east on Delaware Avenue. The large Victorian home seen over the bridge on the right was the home of the Harder family. The house looks over the Normanskill to the family's mill on the opposite shore. (TOB.)

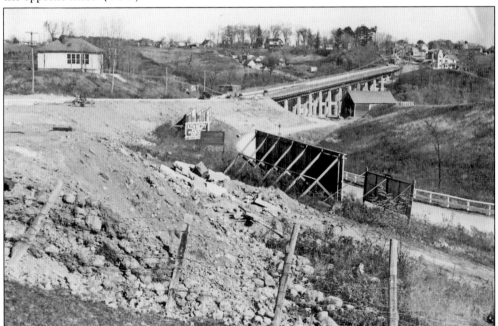

Before the Normanskill Viaduct opened in December 1928, Delaware Avenue traveled a winding path from near Graceland Cemetery down the valley through the hamlet of Normansville, over the creek, and then made its way back up the other side. This Yellow Brick Road, so named for its distinctive paving, was a main thoroughfare complete with billboards advertising local companies. The new high bridge certainly shortened the trip from Albany. The Normansville School can be seen on the left. (TOB.)

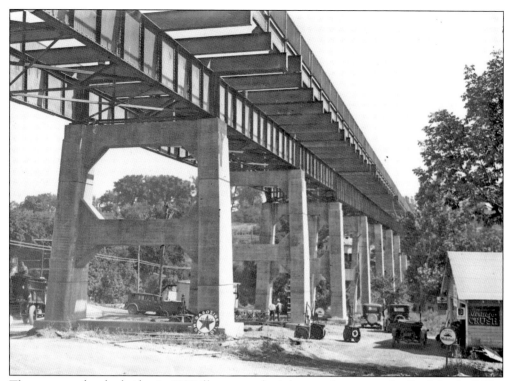

The scene under the bridge in 1928 illustrates why it became known as the "high bridge." The general store on the right advertises Orange Crush as well as Mobiloil. Also note the iconic Texaco star sign. (TOB.)

The waterpower of the Normanskill has attracted investors since Europeans first arrived in the early 1600s. Both the Upper Hollow (Normansville) and Lower Hollow (Kenwood) attracted gristmills for grinding grain, sawmills for cutting wood, carding and fulling mills to process wool fiber, and mills for creating paper. Ice was harvested and stored as well. Shown here is Harder's paper mill at Normansville. It was associated with the Albany City Paper Mills. (TOB.)

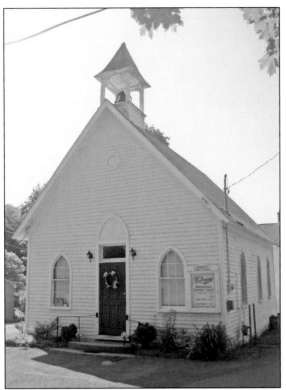

The Normansville Free Chapel was established in 1889, but its first salaried pastor was not hired until 1953. Always nondenominational, it is now known as the Normansville Community Church. The church building, seen here in a modern photograph, has changed little since it was built in 1889. (Courtesy of the author.)

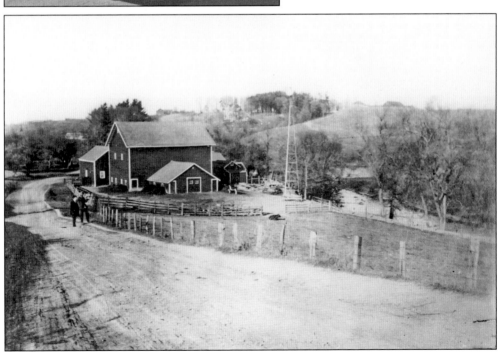

Rockefeller Road through Normansville once connected to Kenwood Avenue. Archive records are unclear exactly where this farm is on Rockefeller Road. The Normanskill may be through the trees, and on the hill in the background may be the Normansville School. (TOB.)

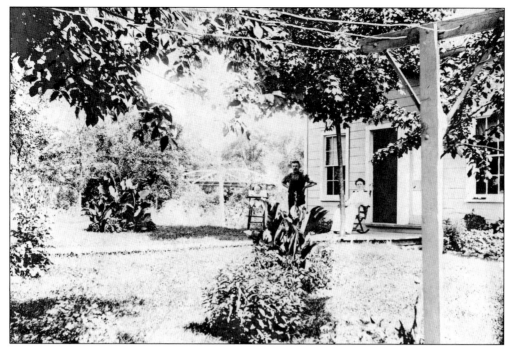

Husband and wife David Baxter and Anna Marie Adams Baxter are in front of their garden shed in the backyard of their Normansville home about 1909. Their son Malcolm is in the highchair. The trusses of the low bridge over the Normanskill can be seen in the background. (Courtesy of Barbara Castle.)

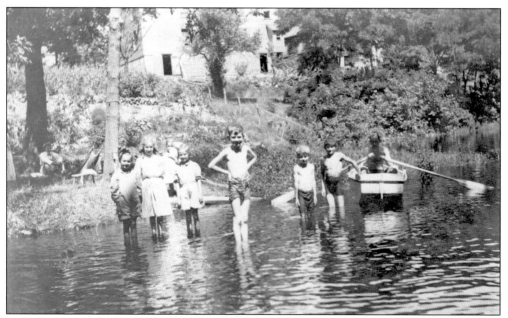

Malcolm Baxter (1908–1987), center, enjoyed a childhood growing up near the Normanskill. Here, about 1918, he plays in the creek behind his home with his cousins. (Courtesy of Barbara Castle.)

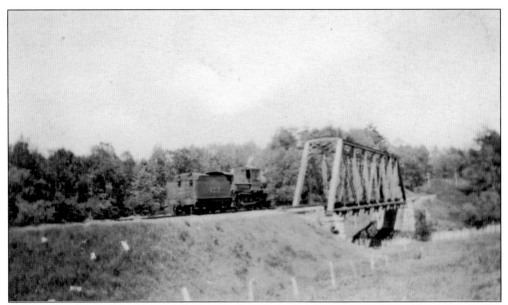

An engine of the Delaware and Hudson Railway crosses the Normanskill at Kenwood in this 1909 postcard. Previously known as Lower Hollow, Kenwood received its name from Jared L. Rathbone. In 1841, Rathbone built his large mansion on the hill north of the Normanskill. He owned extensive woolen mills on the creek and was inspired by a mill village in Scotland to name the area Kenwood. (TOB.)

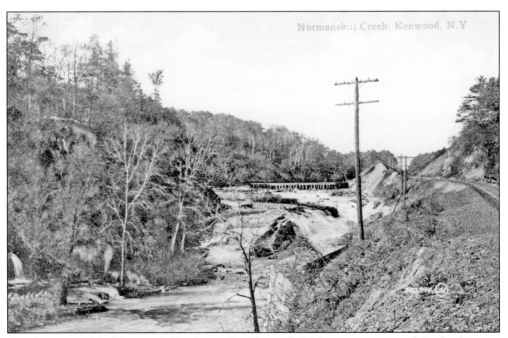

Another view of the Normanskill is featured in this early-20th-century postcard. In the distance is a dam or viaduct over the creek. To the right are the tracks of the Delaware and Hudson as it makes its way from Albany towards Elsmere and Delmar. (Courtesy of Janet Vine.)

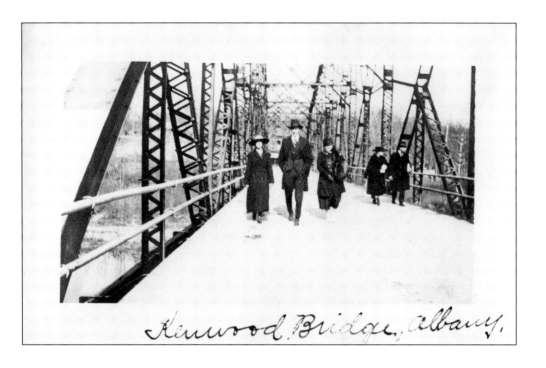

Kenwood Bridge, Albany.

The Kenwood Bridge carries Pearl Street over the Normanskill between Albany and Bethlehem. Such wrought iron, and later steel, truss spans were a common type of bridge from the 1870s to 1930s. Above, folks walk over during the winter. Below is a postcard from the early 1900s. (Above, courtesy of TOB; below, courtesy of Janet Vine.)

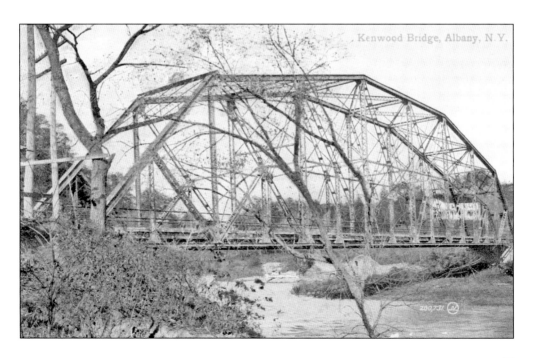

A trolley car nears the old Kenwood Tollgate on South Pearl Street near the Sacred Heart Academy entrance in the early 1890s. Incorporated in 1804, the Albany and Bethlehem Turnpike ran for about five miles from the Albany city line on the Bethlehem Road (renamed Pearl Street in 1870) to Bethlehem Center. From there, a person could take the South Bethlehem Plank Road to South Bethlehem. (TOB.)

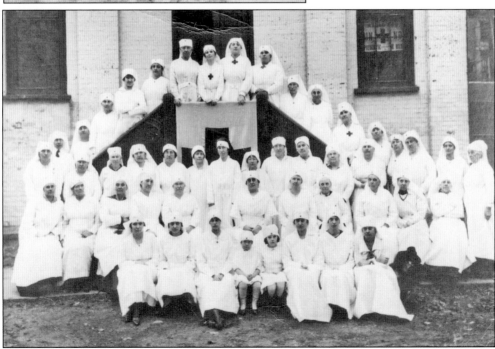

Kenwood had its own schoolhouse, District No. 12. In this photograph probably taken during the World War I era, these unidentified women and girls pose on the front steps in their Red Cross uniforms. (TOB.)

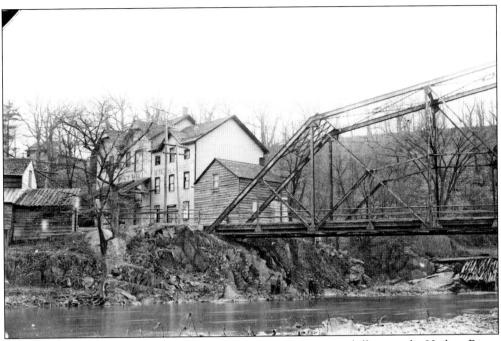

Kenwood, earlier known as Lower Hollow, near where the Normanskill enters the Hudson River, boasted its share of industry. Shown here about 1909 is the gristmill belonging to R.W. Hacher. While the mill was certainly not using waterpower at that time, the remains of the dam over the creek can be seen to the lower right. (TOB.)

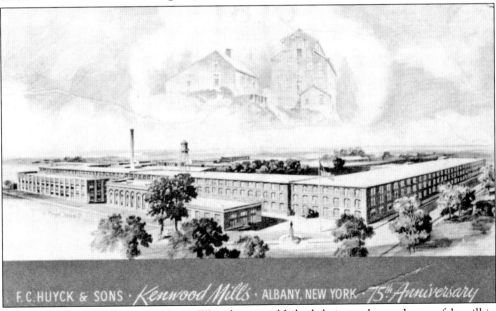

F.C. HUYCK & SONS · Kenwood Mills · ALBANY, NEW YORK · 75th Anniversary

Francis C. Huyck and partner Henry Waterbury established their woolen and paper felt mill in Rensselaerville in 1870. By 1879, they had outgrown the rural site. The partners split up, with Huyck buying a knitting mill in Kenwood and establishing his Kenwood Mills. By the time this postcard was published in 1945 for the company's 75th anniversary, Kenwood north of the Normanskill had been annexed by the City of Albany. (TOB.)

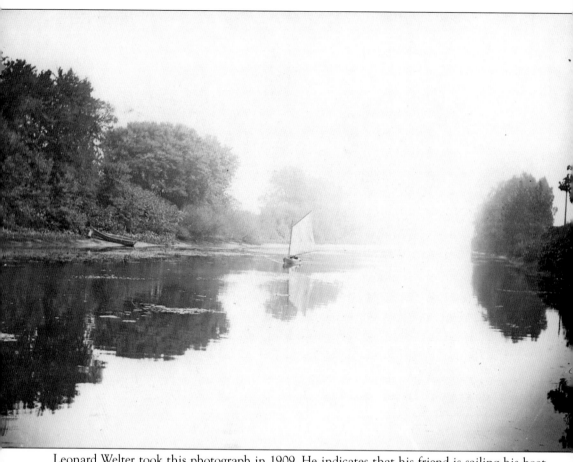

Leonard Welter took this photograph in 1909. He indicates that his friend is sailing his boat toward Albany on the Normanskill. (TOB.)

Six

BETHLEHEM CENTER AND GLENMONT

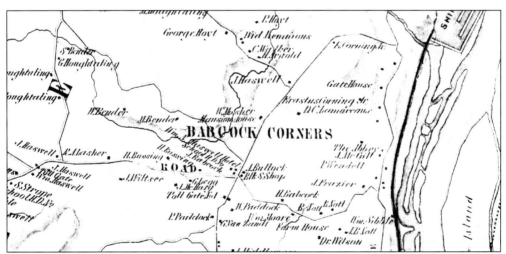

Today's Feura Bush Road travels through the center of this 1854 map. Babcock Corners became known as Bethlehem Center by 1866. Glenmont is farther to the east at Glenmont Road and Route 144 (River Road). Illustrating the fluidity of hamlet names, Bethlehem Center is falling out of use. With Glenmont School and the Glenmont Post Office here, most people refer to the area around Route 9W and Feura Bush Road as Glenmont. (TOB.)

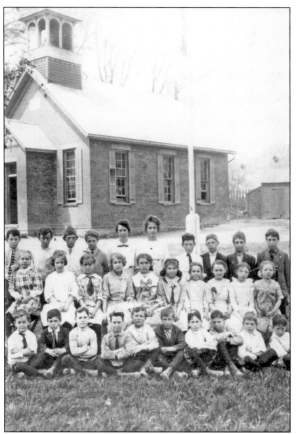

At left, about 1900, students gather in front of the Bethlehem Center one-room school, District No. 7. Below, the new school at Bethlehem Center, built in 1925, dwarfs the one-room structure it replaced. The mid-1920s saw many schools of similar design being built, including the ones in Selkirk, Jericho, and South Bethlehem. All of these, including Bethlehem Center, still stand today, preserved for new uses. Just up the road on Route 9W is Glenmont Elementary School, built in 1956. (Both, TOB.)

The southwest corner of Feura Bush Road and Route 9W looks very different in this circa 1960 aerial picture. William and Bertha Comstock raised their four children on this farm. Just to the south of the farmhouse was the gatehouse for the South Albany Plank Road. Mrs. Babcock was the first gatekeeper, collecting three cents for every sulky, chair or chaise, wagon or cart drawn by a horse. Rates for coaches and stages, flocks of sheep and cattle were also set out. There is still a Mobil gas station on this corner today. (Courtesy of Connie Tilroe.)

In 1852, David Niver invested in the South Albany Plank Road Company. The receipt shown here is signed by John Soop, secretary and treasurer. The South Albany Plank Road incorporated in 1851 to connect Babcock's Corners (Bethlehem Center) to South Bethlehem via a road paved with wooden planks. The planks were to be a hard, even surface for carriages and other vehicles to pass easily over. Road engineers realized that planks were not practical as rot set in quickly and maintenance was difficult. Plank roads soon fell out of favor, with stone and gravel providing better roadbeds. (TOB.)

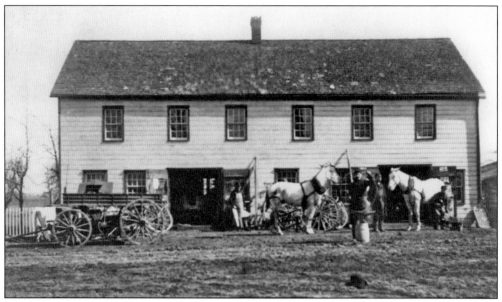

Just about all of Bethlehem's crossroads had a blacksmith shop, and Bethlehem Center was no exception. John Martin opened his shop on the northeast corner of Glenmont Road and the South Bethlehem Plank Road (present-day Route 9W) in 1886 to serve the residents of the district. Forging iron and steel into tools, cooking utensils, horseshoes, and more, blacksmiths were an essential part of the economy. Between the two horses, the smith is posed with his anvil. (Courtesy of Connie Tilroe.)

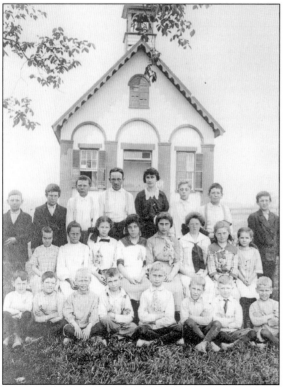

Farther south on Route 9W from Glenmont, almost to Beckers Corners, is another of Bethlehem's one-room schoolhouses, District No. 5. It is usually identified as the Church School because of its proximity to the First Reformed Church, or the Niver School because of its connection to the prominent Niver family. Gerrit H. Niver was killed at the Battle of Little Big Horn while serving with Custer's 7th Cavalry. Niver enlisted as Gerrit H. Van Allen. According to family tradition, he and his brother headed west in the 1870s under assumed names to protect their mother's ill health. Gerrit went as Van Allen and his brother Conrad as John Eddy. (TOB.)

Route 9W looks like a country lane in this photograph dated June 22, 1943. Previously known as Myers Corners, for the owner of the large farm shown here, this intersection has been reworked many times over the past years. The road to the right leads to Jericho Road and Elm Avenue. Today, the Jericho Drive-In occupies the large field to the right, and the farmhouse and barn are concealed behind trees and shrubs. (BHA.)

Looking north on Route 9W on November 25, 1952, one can glimpse the silos of Heath's Dairy Farm. William and Elvira Heath bought the property in 1920 and ran a dairy here until the 1980s. Starting with 67 acres and 19 cows, the operation grew to 450 acres and 225 Holstein cows. Heath's Dairy included a home delivery service and a store located on the premises. In 1955, customers could enjoy a glimpse of the milking parlor located next door. (BHA.)

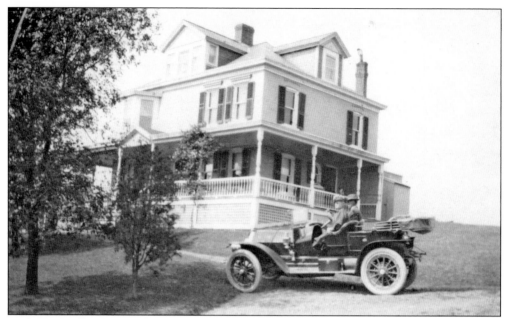

Records identify this photograph as simply the "Patterson House, Glenmont Hill." Glenmont Hill rises up from the flats near the Hudson River along today's Glenmont Road. In 1891, at the base of the hill on River Road, Glenmont was a bustling hamlet that included J. Patterson's large property, a station on the West Shore Railroad, the New York Sand and Facing Co., and the Abbey Hotel. (BHA.)

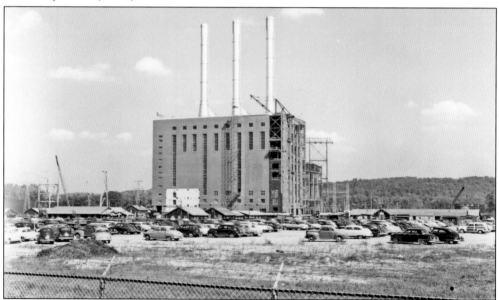

In this view taken on September 25, 1952, construction is underway on the Niagara-Mohawk Steam Generating Plant located on Route 144 (River Road.) Upon completion, it generated 320,000 kilowatts. The Niagara Mohawk Power Company consolidated in 1950 to provide electricity and natural gas to Upstate New York customers. By 1958, its system had expanded to cover 21,000 square miles of New York State, with 83 hydroelectric plants, seven steam-driven plants, and several thousand miles of natural gas mains. (BHA.)

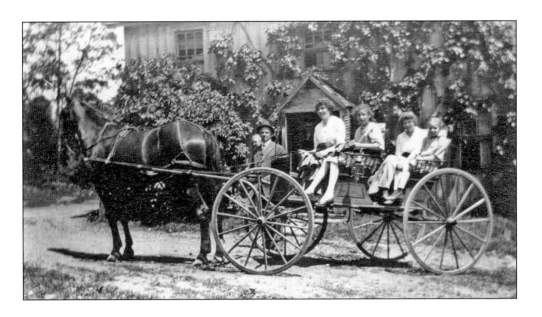

Above, Anna Glaser, left holding the reins, and her three cousins pose in their horse and wagon in front of the Glaser's family home, also known as the Gerret Vandenbergh House. Below, a dog frolics in the snow in a 1903 photograph of the home. The original brick part of the house was built on the flats near the Hudson River in the 1730s. During the American Revolution in 1775 and 1776, Lt. Gerret Vandenbergh served with the 5th Regiment of the Albany County Militia, 3rd Rensselaerwyck Battalion. The last family to own the house was the Glasers, who lived there from the late 1890s until 1931. That is when Sun Oil purchased the property, and the house was demolished. Later, the Niagara-Mohawk Steam Generating Plant was built at this location. (Both, BHA.)

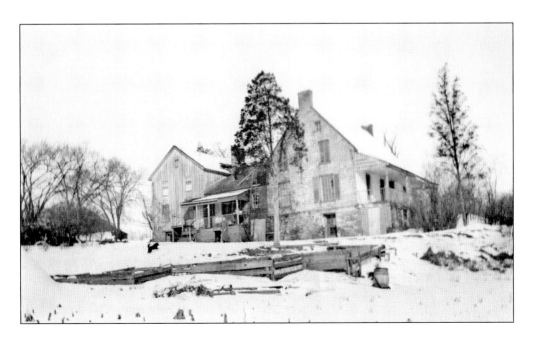

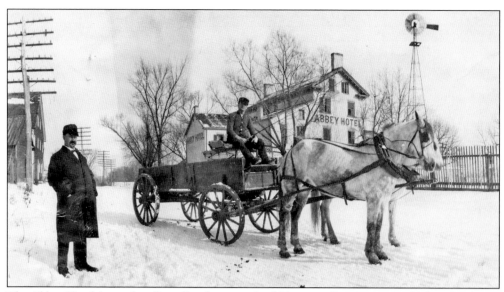

The Abbey Hotel, located on River Road just north of Glenmont Road, was a Bethlehem landmark for over 200 years. It is believed to have been established in the early 1700s by one of the Van Rensselaers. Through its many incarnations, the Abbey Hotel offered weary travelers on the River Road and the Hudson River lodging and refreshment and served as a gathering spot for reunions and politicians. It was later a well-known roadhouse and even rumored to have been a Prohibition-era speakeasy. The Abbey was vacant by 1945 and razed in 1961. (Courtesy of the Wisconsin Historical Society.)

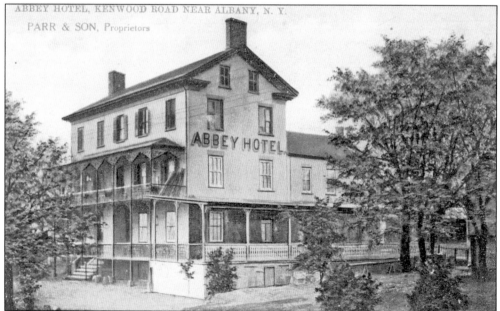

When Henry Parr took over the Abbey Hotel in 1881, he connected it to Parr's Island via a bridge and causeway over the Hudson River. Guests could enjoy the harness track, picnics, clambakes, swimming, and camping. Docks provided mooring for visitors arriving by boat as well excursion boats offering scenic trips on the Hudson River. Parr also had an icehouse and his farm on Parr Island. In 1898, he planted 80,000 cabbages. (Courtesy of Janet Vine.)

An outing to Parr's Island Park in 1914 might include a family photograph. Behind the wheel of the Buick Phaeton is William A. Glenn, with "Grandpa" John M. VanDerzee next to him holding Elizabeth Eleanor Glenn. In the back seat are great-grandmother Hannah Conger, grandmother Catherine M. VanDerzee, and mother Nettie M. Glenn, holding Catherine M. Glenn. (BHA.)

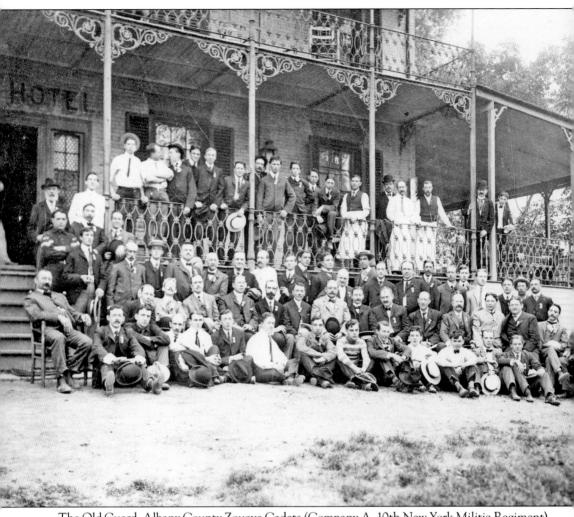

The Old Guard, Albany County Zouave Cadets (Company A, 10th New York Militia Regiment), poses on the porch of the Abbey Hotel during its anniversary gathering on June 6, 1903. Henry Parr, owner of the Abbey, is seated in the chair at left. In the United States, Zouave Cadets volunteered for service during the Civil War and were known for their distinctive North African–inspired uniforms. The Union had over 70 Zouave units, and the Confederates had about 25. (TOB.)

Seven

VAN WIES POINT AND CEDAR HILL

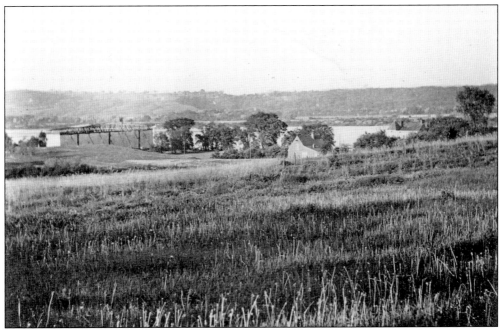

The Van Wies Point area, also known as Dominie's Hook, is seen in an early-20th-century view. In the distance is the Hudson River. To the left is an icehouse, and on the right is a glimpse of the towers of Bonnie Castle. Hendrick Van Wie leased land from the Van Rensselaers here in 1679. In 1835, the Hudson River Steamboat Company leased land from the Van Wies for its Albany Terminal. Passengers disembarked here and took a stagecoach to Albany. (BHA.)

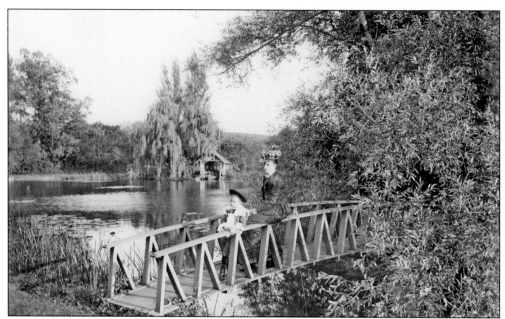

About 1887, John Allan Terrell and Elizabeth Van Allen Terrell relax on the bridge at picturesque Frothingham Lake. The Frothingham's large summer home overlooked the lake and the Hudson River and was once owned by Ten Eyck Mosher, a prominent Albany real estate man. Private roads entered these summer estates from River Road (Route 144). Mosher Road most likely started off as a private road. The pillar marking its entrance bears the date 1865. (BHA.)

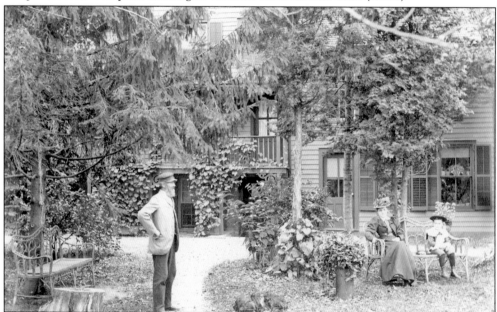

Through the trees one can glimpse Charles Lansing's summer estate in this 1897 photograph. Lansing, and later his son Gerit, enjoyed views of the Hudson River from the porches of their elegant Van Wies Point home. Standing is G.Y. Lansing. At the turn of the 20th century, many wealthy Albany residents enjoyed the cooling river breezes at their summer places, including sculptor Erastus Dow Palmer, who lived at Appledale. (BHA.)

Bonnie Castle, the Hailes family's summer home, was built in 1891 and overlooks the Hudson River at Van Wies Point. Dr. William Hailes (1862–1912) was an Albany pathologist associated with Albany Medical College. His wife and daughter continued to live here until 1924. This photograph, taken on December 27, 1953, shows the back of the house. The front entrance hall faces the river. Hailes intended the prominent tower to be an observatory, an idea that was never realized. (BHA.)

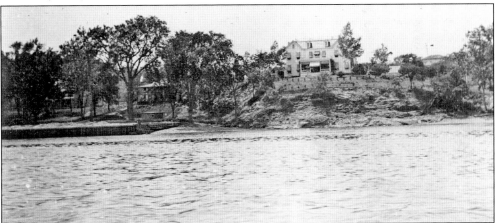

Rock Ledge on Van Wies Point is seen from the Hudson River in the early 20th century. Built in 1904, Rock Ledge is thought to have served as the summer home of Chauncey Hakes and his family. Hakes, an Albany businessman, was a member of the Albany Automobile Club. In 1908, he helped organize the club's reception of racers participating in the New York to Paris Race sponsored by the *New York Times* and *Le Matin*. The racers departed New York City on February 12, passed through Albany and then headed west. Some 169 days and 22,000 miles later, the American Thomas Flyer team was the first to arrive in Paris, France. (BHA.)

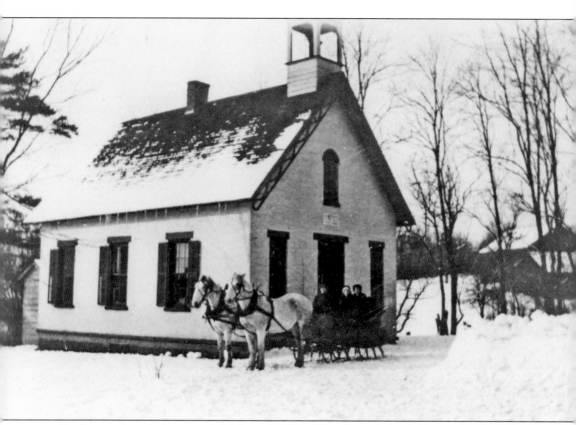

Students arrive via horse and sleigh to the Van Wies Point School, District No. 6. This one-room school still stands on River Road. Before the familiar yellow school bus made its rounds, Bethlehem's children walked to school. Perhaps they were able to hitch a ride on a farm wagon, or as in this picture, a sleigh. Besides their lunch, students often had to bring firewood or coal to feed the stove that heated the building. From the time it was built in 1863 until centralization in 1930, the school had students in first through eighth grades. From 1930 until it closed in 1949, students attended here in grades one through six. According to the *Knickerbocker News*, the commissioners of the district sold the school and required that the building "shall not be used for the manufacture, sale or distribution of intoxicating beverages—nor for the business of raising pigs." Mr. Lightsey, an Albany plumber, purchased the schoolhouse to make a home for his family. (TOB.)

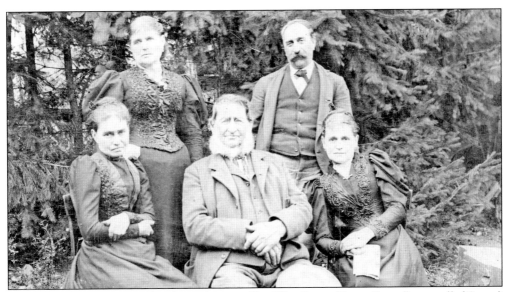

Members of the John Staats family are shown at Van Wies Point. Abram Staes (later spelled Staats) arrived in Fort Orange from Holland on August 4, 1642. With his wife, Trijntgen Jochemse, and their seven children, they established the Staats family in Albany and Rensselaer Counties. In Bethlehem, members of the Staats family owned land in the Van Wies/Cedar Hill area across the Hudson River from Staats Island. Maj. Barent Staats from Bethlehem served the patriots' cause during the American Revolution. Members of the family were also active with the First Reformed Church of Bethlehem. (BHA.)

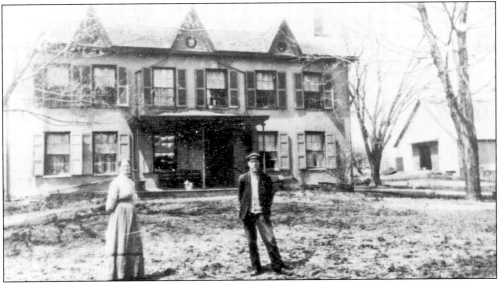

The Kimmeys were a well-known Bethlehem family, established here as early as 1798. Various members of the family had farms and properties in the southern part of town, including South Bethlehem, which was known as Kimmeys Corners for a time in the 1850s. William Kimmey served as town supervisor from 1863 to 1866. This photograph is identified as the "Kimmey Farm and Dutch Barn at Cedar Hill." The 1866 Beers map of Bethlehem locates a J.D. Kimmey east of River Road just south of today's Wemple Road. The Dutch barn with its distinctive gable end door is visible on the right. (TOB.)

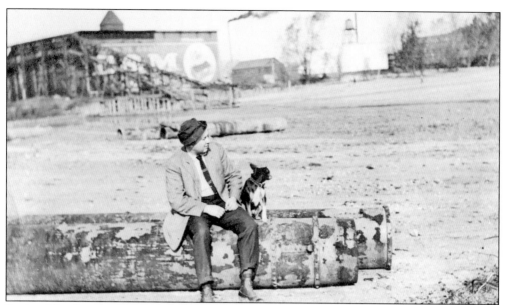

Fred and his dog Fritz enjoy a November day in 1914. In this image taken at Westerlo Island (at the time still part of Bethlehem), the old Schifferdecker icehouse is in the background. Note that Fred and Fritz are on dry land with the ice chute seen in the distance. The chute was located in or very near the water source so that blocks of ice could be floated to the icehouse. Most likely, as the cold days of winter approached, Schifferdecker, like other companies, flooded the flat area with clean water for harvesting after it froze. (BHA.)

On the far shore of the Hudson River, an icehouse sends its chute down to the waters. Also visible upon the water is a steam-powered launch. The photograph was taken in the early part of the 20th century. (BHA.)

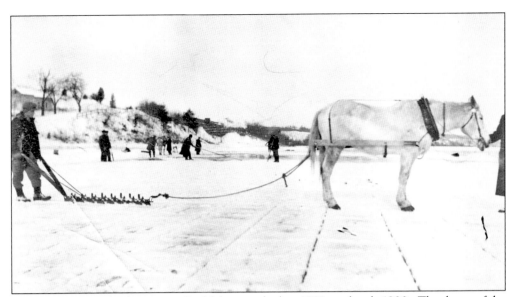

Ice harvesting was big business in Bethlehem in the late 1800s and early 1900s. The shores of the Hudson River from Albany to New York City were lined with enormous icehouses that stored the blocks of ice for summer consumption. Bakers, Schifferdecker, Best, and Tilly & Littlefield are some of the icehouses found on Bethlehem's shores. In the slow time in winter, Bethlehem's farmers looked forward to the extra income made from working the ice harvest. Both men and horses worked out on the rivers or ponds scoring the ice and sawing up the cakes that were then floated to the icehouse. The cakes were packed in massive stacks with hay, straw, or sawdust providing insulation. Some of the ice was used for local consumption, and large quantities were sent on barges to New York City. Above, the ice is scored before breaking up the cakes. Below is Dettinger's Ice House on Van Wies Point about 1900. (Both, courtesy of Kim Salamida.)

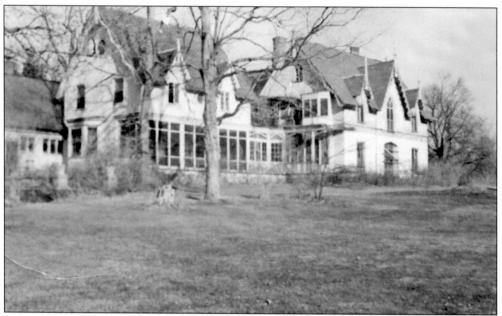

J.B. Lyon, owner of a successful printing company and other business interests in Albany, purchased a large tract of land at Cedar Hill in 1887 from John Taylor Cooper. Slowly, he transformed Cooper's modest house into the spacious summer home pictured here. By his retirement in 1916, Lyon and his wife, Anita, were living here year-round. While the main house burned in 1964, a rustic bungalow on the shores of the Hudson remains today. Two of the large sculpted lions that marked the entrance roads to the Lyon estate are still in place on Barent Winne Road. Below, J.B. Lyon often took visitors to his summer home via the Hudson River aboard his steam-powered launch. (Both, BHA.)

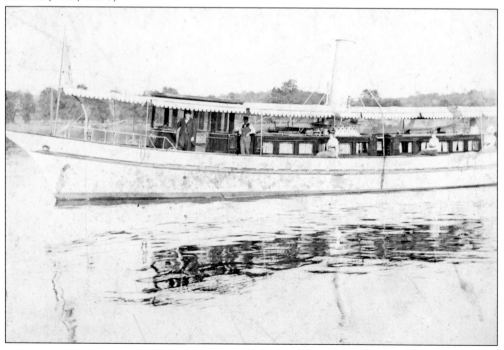

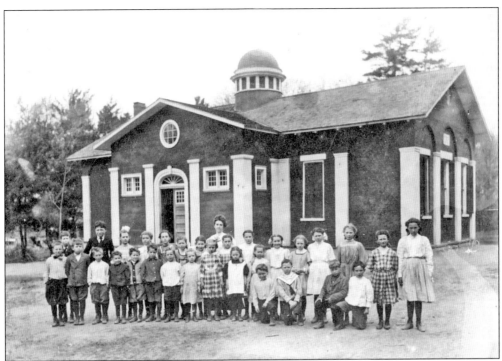

Cedar Hill had the first school in town, built of logs in 1720 at the Nicoll Farm near the Hudson River. The Cedar Hill Schoolhouse, District No. 1, was built as a one-room school in 1859. In 1907, Marcus Reynolds designed its expansion to two rooms, which is how the building looks today and in this early 1900s photograph. The expansion included indoor plumbing and electricity. Two teachers educated 40 students in grades one through eight. Due to school centralization, classes ended here in 1962. The schoolhouse is now home to the Bethlehem Historical Association. (BHA.)

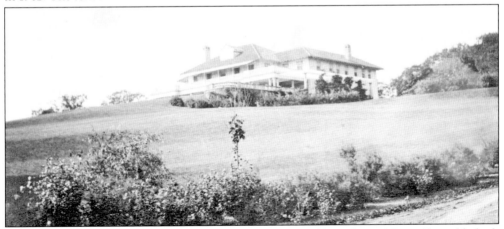

Martin H. Glynn (1871–1924) had his summer home, designed by architect Marcus Reynolds, built in 1907. Glynn was elected lieutenant governor in 1913 and, following the impeachment of Gov. William Sulzer, became governor of New York from 1913 to 1914. While prominent in political circles, Glynn was also a noted journalist who became owner, publisher, and editor of the *Albany Times Union*. Later, the house was sold to Daniel Prior, a famed Albany defense lawyer whose clients included Jack "Legs" Diamond. For many years, the building housed the Elks fraternal organization, and it still stands on River Road today. (BHA.)

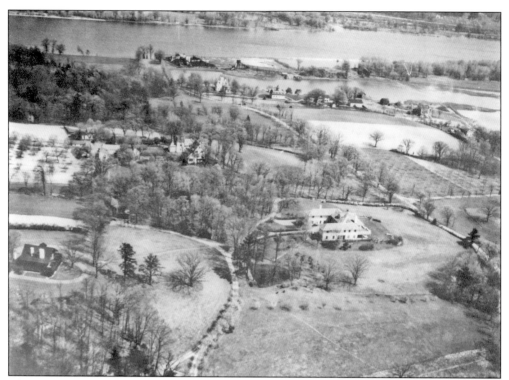

There are many landmarks to point out in this bird's-eye view of Cedar Hill taken before 1965. The large home shaped like a backwards C is the Governor Glynn Mansion, built as his summer home in 1907. Following Barent Winne Road (on the right) towards the Hudson River leads to a glimpse of the George Best House (built about 1870) and the charred remains of an icehouse. This is the location of today's Henry Hudson Park. In between Glynn's house and the Hudson River is the Lyon home. The carriage road in the foreground leads to River Road (Route 144). (BHA.)

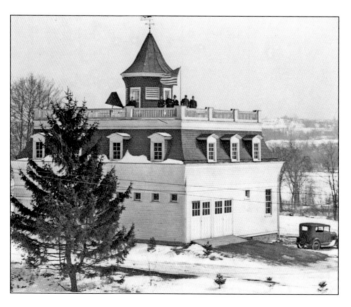

As part of Bethlehem's civil-defense measures during World War II, an observation post was established at this Cedar Hill carriage house. Many citizens, including chief observer Thomas Finley and assistant chief Esther Hillman, volunteered to man the post 24 hours a day to listen and watch as part of the Army's Aircraft Warning Service. The large horn contains a microphone to help locate high-flying planes by sound. Volunteers received special training in aircraft recognition. (TOB.)

Barent Staats Winne Sr., a descendant of two early Dutch families, ran a successful freight and barge business at Cedar Hill. Winne's dock was a busy operation, with local products such as lumber, oats, hay, and ice being shipped out and other goods such as coal, furniture, and hardware being received from distant ports for local consumption. He built the home above near the dock about 1860, and the property included a general store as well as storage facilities. His son Barent Winne Jr. continued the operation until his death in an auto accident in 1932. He faced a difficult business climate with railroads bringing increased competition. The house remained the home of his wife, Lena VanDerzee, until the early 1960s. Below, in 1910, a steamer awaits passengers at the Cedar Hill dock. (Above, TOB; below, BHA.)

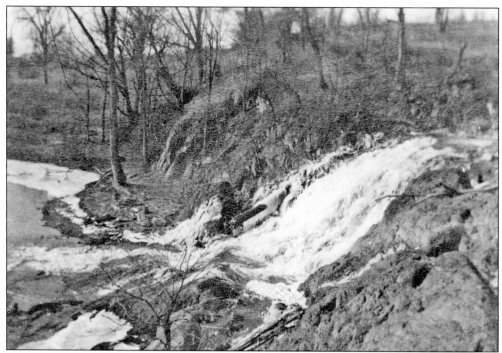

Hidden behind a home on Lyons Road, these falls on the Vlomankill provided waterpower for early settler Pieter Winne de Vlaumingh (*de Vlaumingh* means "the Fleming"), who came here in 1677. The creek is named after him. Later maps indicate a plaster mill in the area. Today, Lyons Road leads to Henry Hudson Park and the Hudson River. In days gone by, the road led to the Cedar Hill landing, where farmers could find barges to transport their cash crops to markets such as Albany and New York City. (TOB.)

David Jones was a Cedar Hill resident who, on May 20, 1843, leased William N. Sill's store at Cedar Hill for $40 a year. Jones received the above notice to appear "armed and equipped as the law directs" for the company parade at the house of Walter Becker on the Fourth of July 1838. At this time, able-bodied men were expected to assemble for militia training once a year. These parades often had a party atmosphere until the New York State Militia was reorganized in 1846. (TOB.)

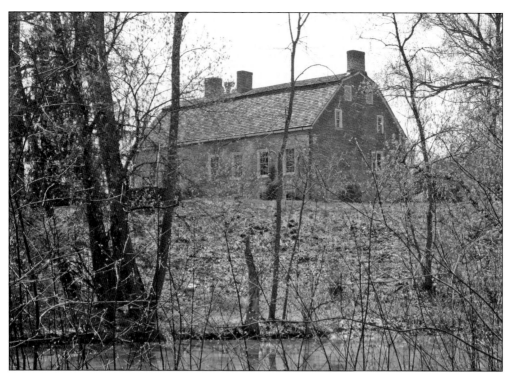

Constructed about 1735, the Nicoll-Sill, or Bethlehem House, was built near the Vlomankill for Elizabeth and Rensselaer Nicoll on part of their 1,300-acre estate. Nicoll was a member of the powerful Van Rensselaer family through his mother, Anna Van Rensselaer. Elizabeth and Rensselaer's son Francis served during the American Revolution. Francis's daughter Elizabeth Nicoll Sill inherited the property, and it remained in the Sill family until 1875. Seen from the creek in this modern view, the large manor home seems little changed from the late 1700s; however, the home on Dinmore Road has been greatly expanded and modified over the years. (Courtesy of the author.)

Pieter Winne, grandson of Pieter Winne de Vlaumingh, built this home about 1720. Pieter was baptized at the Albany Reformed Church in 1699 and married Rachel VanAlen on January 21, 1720. Seen here in a modern view, this early Dutch-style home is being carefully restored by Brian Parker. (Courtesy of the author.)

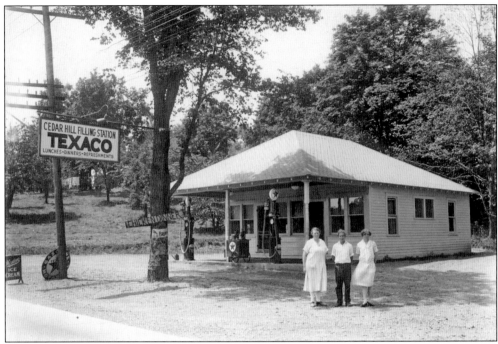

In 1922 Ray Golden Sr. and his wife Jennie opened the Cedar Hill Filling Station on Route 144 at the corner of Beaverdam Road. One could fill up the tank with Texaco and then go inside for a hot dog or pineapple ice cream sundae or perhaps the chicken dinner advertised. Standing outside are, from left to right, Martha Whitbeck, her nephew Carmen Whitbeck and Jennie Golden. The same three are inside with Martha Whitbeck on the left, Jennie Golden center, and Carmen on the right. The pictures were taken about 1933. The Golden's sold the property to Ann "Ma" Cole who ran a tavern here for many years. (Both, courtesy of Gail Drobner.)

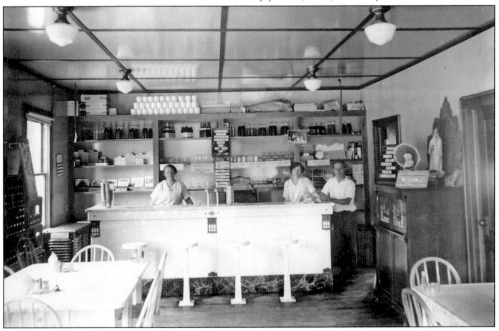

Eight

SELKIRK

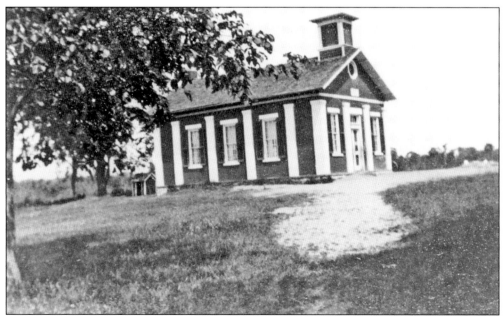

Selkirk's one-room school, District No. 2, was built in 1859 on Old Ravena Road. It most likely replaced an earlier building. The school standing on Thatcher Street today was built in 1928 and replaced this one. In 1947, Selkirk and other districts in the southern part of town centralized into the Union Free District No. 1, becoming part of the Ravena-Coeymans-Selkirk Central School District in 1956. (TOB.)

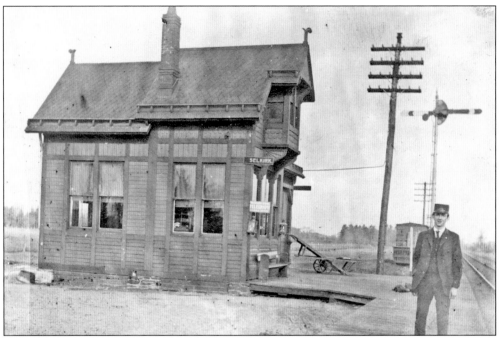

The West Shore Railroad built the Albany Branch that runs through Selkirk in 1883. The West Shore was begun in 1874 to compete with the New York Central in the days of the railroad barons. By 1886, the New York Central took over the line, although it continued to use the West Shore name for many years. Regularly scheduled trips to Albany brought more development to the hamlet and meant folks could live in a quiet rural community and travel to the city for work and shopping. The station was constructed about 1883 near where the tracks cross Maple Avenue on land belonging to members of the Selkirk family. Their ancestor, James Selkirk, a Revolutionary War veteran, settled here in 1786. Above is the station in the early 1900s. Below, 50 years later, very little seems to have changed. Records note that this is the No. 8 train from Albany to Weehawken, New Jersey. Passenger service stopped in Selkirk in 1959. (Above, BHA; below, TOB.)

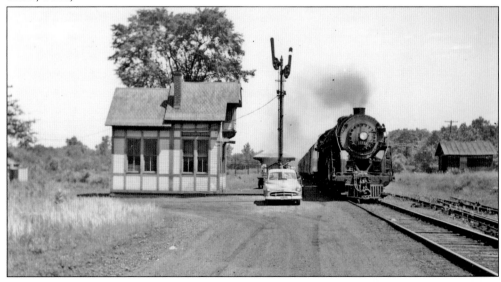

At right, in an undated photograph, Orville Hoffman (in derby) and a companion wait at the Selkirk railroad station. Below, Kenwanee Boilers from Security Supply Corporation await shipment on the freight dock next to the passenger station. Also near the station were large piles of molding sand awaiting freight cars. Molding sand, used in metal casting, was an important Bethlehem commodity. Farms for sale or auction would list the acres of molding sand available. These sandpiles could also be found near the Slingerlands freight station. (Right, BHA; below, courtesy of Security Supply Corp.)

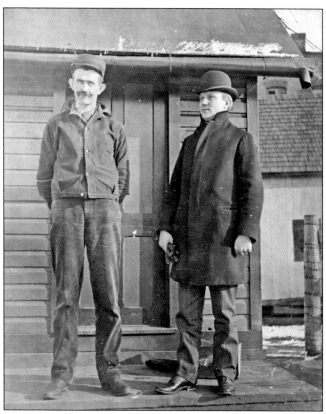

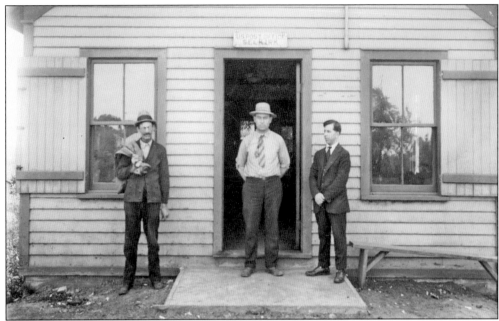

Michael Mangini, William Winne, and another gentleman stand in front of the Selkirk Post Office about 1920. The post office was established in 1883 by Jacob J. Soop and located at the railroad station. The post office at Beckers Corners (established in 1873) merged with Selkirk in 1899. The one at Cedar Hill (established in 1833) joined in 1901. Soon thereafter, rural free delivery covering 20 square miles was established in Selkirk. At the time, the route served just 925 addresses, a hint of the southern part of Bethlehem's rural character. (BHA.)

William M. Bennett, age 22, moved to Selkirk in 1923 and began a plumbing contracting business on Maple Avenue. Bennett, along with partners Harold L. Williams Sr. and Earl D. Vadney, saw an opportunity during the Depression years to get into the supply side of the business, and they established the Security Supply Corporation in 1934. The company continues today as a successful, family-run wholesale distributor of plumbing, heating, and air-conditioning products. The cement block building shown in this 1952 photograph was constructed in 1931. (Courtesy of Security Supply Corp.)

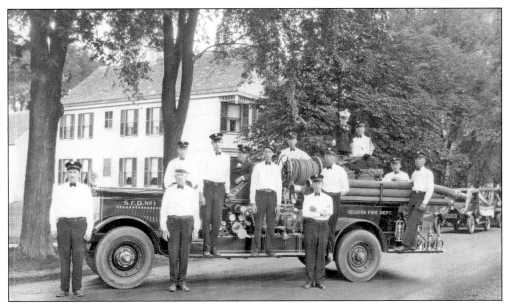

The Selkirk Fire District was established in 1928, and its first alarm was a fire at a hay barn on the Wilsey farm. In 1931, members participated in a parade at Ravena. From left to right are (standing on pavement) William M. Bennett, Chief J. Bronk Van Derzee, and George Young; (on the truck) William Pausley, C.J. Woerhmann Jr., A.J. Lehmann, Rubin White, Allen Winnie, C.J. Woerhmann, Donald Hansen, Charles Hansen, William Newberry, and Peter Hoffman. (BHA.)

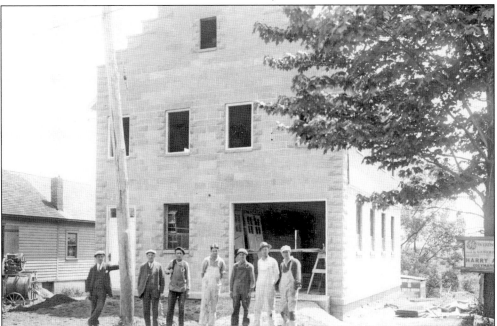

Construction of the new Selkirk firehouse began on April 7, 1928, on land on Maple Avenue purchased from a Mrs. Bull for $6,250. From its beginning in 1928, the Selkirk Fire District grew to cover a large part of Bethlehem, including the majority of the southern part of town. Company No. 2 was established in 1952 with the firehouse on Glenmont Road, built in 1953. Company No. 3 was added in 1956 with a firehouse on Bridge Street in South Bethlehem. (BHA.)

A snowy scene in 1921 shows the E.H. Freleigh candy story on the left and Lehmann's Garage on the right. The candy store is in the same building as the Selkirk Post Office. (TOB.)

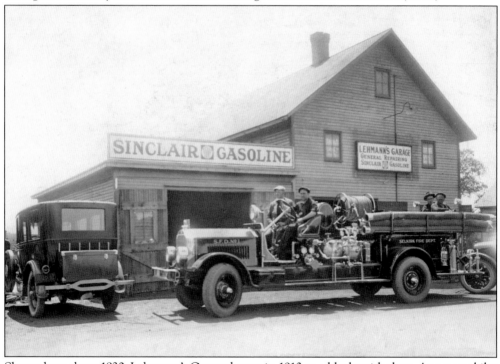

Shown here about 1930, Lehmann's Garage began in 1913 as a blacksmith shop. As automobiles became popular, the business transitioned to gasoline sales and auto repair. Members of the Lehmann family still run an automobile repair shop here today. Lehmann's Garage is the oldest business in town run by the same family. "Dutch" Lehmann is behind the wheel with Bronk Vanderzee beside him. To the rear are Carlton Holcomb (left) and Albert Jacob Lehmann. (BHA.)

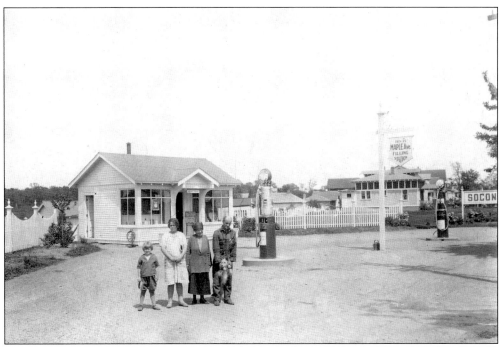

The Maple Avenue Filling Station provided Socony (Standard Oil Company of New York) products in 1928. Members of the Hood family are shown. Small filling stations such as this one dotted the roads of Bethlehem. (TOB.)

Charles Henry Selkirk established his poultry farm in 1917. Charles, and later his son Robert and grandson Ron, continued the business even when the New York State Thruway went through the best part of their land in 1954. Their farm store, shown here in 1960, had a good run from about 1960 to 1968. Ron and his wife, Judy, live today on the west end of the farm, which is off Maple Avenue. (Courtesy of Ron Selkirk.)

The official opening of the New York State Thruway segment from Westmoreland to Newburgh was a big event on October 26, 1954. Governor Dewey waved to bystanders as his motorcade passed under the Maple Avenue Bridge. This photograph was taken either by Robert or Sibyl Selkirk, who gave up part of their farm for construction of the thruway. (Courtesy of Ron Selkirk.)

Selkirk hosted its share of large summer homes. On the bluff above the Hudson River, General and Mrs. Patterson built this lovely house in 1901. It was designed in the popular Colonial Revival style to be their summer residence. The 15 acres of land associated with the property were owned by Grace Patterson's father, William Law Learned. He had purchased a large summer estate here in 1870. The photograph was taken about 1920. (BHA.)

Tradition has it that the congregation of the First Reformed Church of Bethlehem began meeting in 1763. The church was formally incorporated as the First Reformed Protestant Dutch Church of Bethlehem and Jericho in 1791. In 1798, the Reverend George Bork became the first permanent ordained minister. He conducted services in English and Dutch. The church at right was erected in 1821 and burned down on March 9, 1890. The interior view below, from a 1908 postcard, is of the church that still stands today, which was built in 1890. A large pipe organ dominates the view, and the chandeliers are lit by gas lamps. (Right, TOB; below, courtesy of Gail Drobner.)

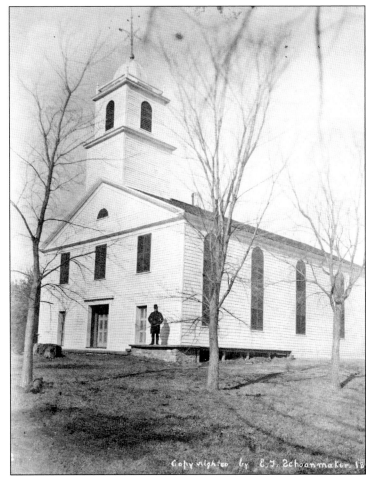

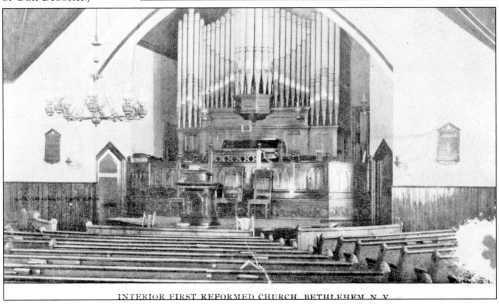

INTERIOR FIRST REFORMED CHURCH, BETHLEHEM, N. Y.

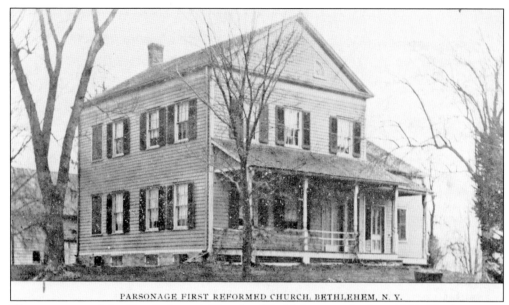

PARSONAGE FIRST REFORMED CHURCH, BETHLEHEM, N. Y.

The parsonage of the First Reformed Church of Bethlehem was built in 1844. The home was named "The Lucretia," after the wife of the first pastor to live there, the Reverend Ralph Willis. Today, it is still in use as the parsonage. (TOB.)

Walsh Construction Company employees take a break from working on the roundhouse at the Selkirk Railroad Yards. When the yards opened in 1924, there were two roundhouses with a capacity of 62 locomotives. The yards included many tracks and sidings where managers sorted out freight cars depending on their destination. The photograph was taken by Wilbur Hallenbeck, who worked on the project. (TOB.)

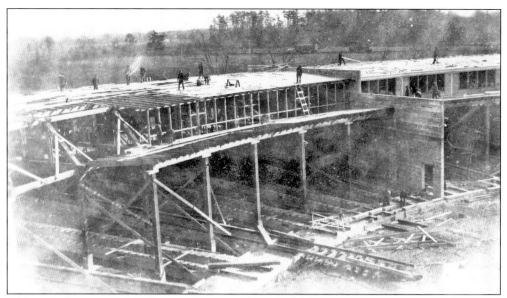

Above, work continues on the roundhouse at the Selkirk Railroad Yards. The Castleton Cut-Off project, conceived by Alfred H. Smith in the early 1920s, included the Castleton Bridge that carries the New York Central's tracks over the Hudson River and the Selkirk Railroad Yards where freight cars are sorted and classified. The cutoff relieved congestion at the Albany Railroad Yards, and the rural setting left plenty of room for expansion. Completed in 1924 at a cost of $25 million, the yards were said to be the largest of their kind in the world. The Selkirk Railroad Yards continue to be an active enterprise today. Below is a view of the yards taken on August 20, 1949. (Above, TOB; below, BHA.)

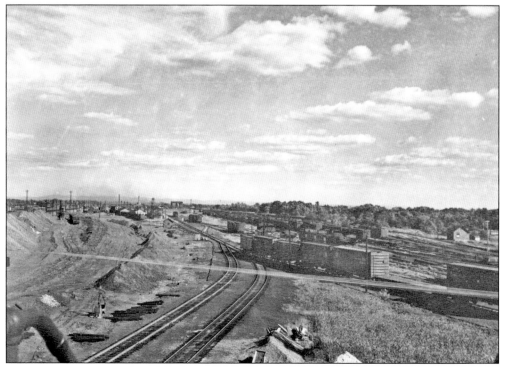

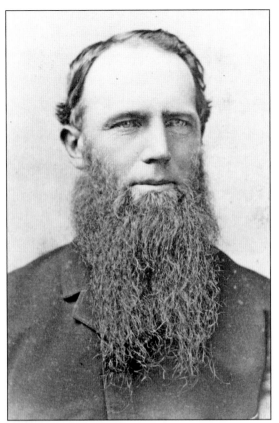

The Becker family has a long history in the town of Bethlehem starting with the first Albertus, a native of Holland who settled here as early as 1767. His grandson Albertus W. Becker built the brick home (below) on the family farm along Route 396, near what is now known as Beckers Corners, upon his marriage to Polly VanderHeyden in 1800. In 1851, the house came into the possession of the second Albertus grandson, Albertus W. Becker (left), when he was just 17 years old. Becker was elected to the post of town supervisor in 1862 when one responsibility was to recruit volunteers for the Civil War. He was again elected in 1871 and served through 1874. Becker had many other business and community interests, including the South Bethlehem Plank Road Company, the Bethlehem Mutual Insurance Company, and the Bethlehem Conscript Society (organized in 1875 against horse thieves.) He was married to Anna Haswell and had three children. The homestead is shown here in 1899, when it was owned by Legrange Winne. (Left, TOB; below, BHA.)

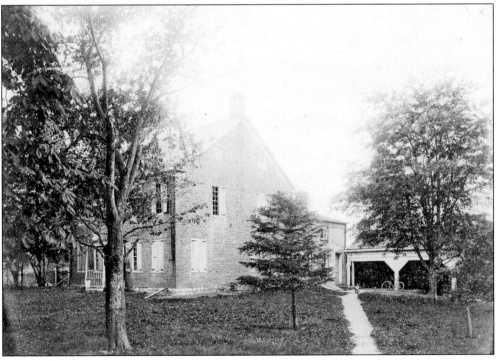

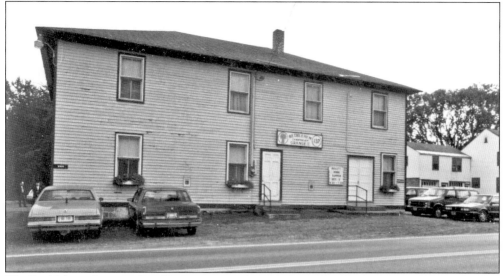

The Bethlehem Grange No. 137 was organized in 1874 to promote agriculture and the interests of farmers. In 1880, members built their first hall on land purchased from Albertus Becker. Later enlarged in 1900, this original hall burned to the ground on New Year's Day 1920. A new hall was dedicated on February 22, 1921. It was enlarged in 1936 and differs very little from this 1991 photograph. (Courtesy of Gail Drobner.)

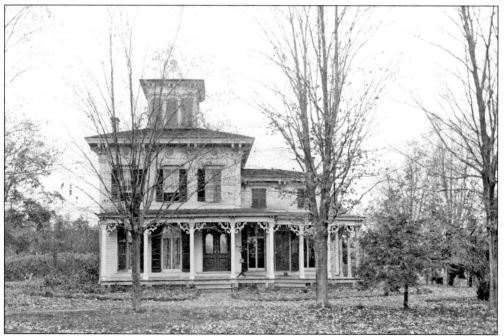

Jurian Winne's lovely Jericho home was removed for construction of the Selkirk Railroad Yards. Winne (1817–1886) was a progressive farmer, participating in many activities to promote the advancement of agriculture. He was one of the organizers of the Albany County Agricultural Society, vice president of the New York State Agricultural Society, and the first master of the Bethlehem Grange (founded in 1874). Winne also raised prizewinning Leicester sheep and was an expert on their winter feeding. (BHA.)

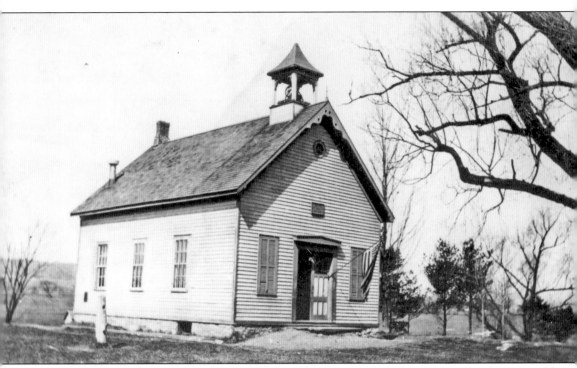

Jericho is another place name in Bethlehem that is not popularly recognized today. It would roughly have been in the Jericho Road–Creble Road area. The Jericho schoolhouse, District No. 4, pictured here, was most likely replaced by the 1920s-era school that still stands on Old School Road. Jericho remained a common school until it joined with other schools in the southern part of town to form the Union Free School District No. 1 in 1947. Union Free merged to form the Ravena-Coeymans-Selkirk District in 1956. (TOB.)

Nine

SOUTH BETHLEHEM

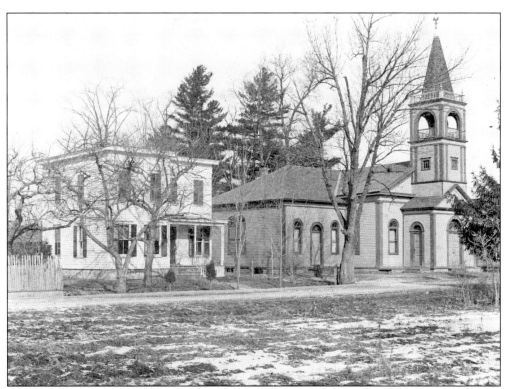

The South Bethlehem United Methodist Church was formed in 1823. Its original church building near Beckers Corners was taken down in 1845, and some of the timbers were used to build a new church on Church Street, now Willowbrook Avenue (pictured). It was formally dedicated in February 1846 as the First Methodist Episcopal Church of Bethlehem. The hamlet was then known as Janes Corners. William Janes (or Jaynes) was an early settler in the area, and Elishama Janes had a tavern. By 1854, the area was known as Kimmeys Corners, after hotel owner P. Kimmey. The 1866 Beers map lists the area as South Bethlehem. (BHA.)

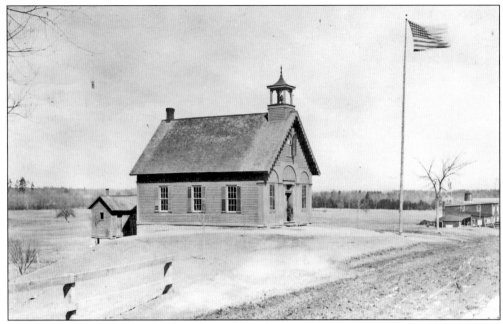

This fine-looking wooden school was built along present-day Bridge Street in South Bethlehem, probably in the 1850s. The District No. 3 School was replaced in the 1920s by the larger brick building that stands on South Albany Road and is today a private residence. South Bethlehem continued as a common school until 1947 when it combined with other districts in the southern part of town to become the Union Free School District No.1. Union Free merged in 1956 to become the Ravena-Coeymans-Selkirk Central School District. In the distance to the right is Aussem's sawmill. (TOB.)

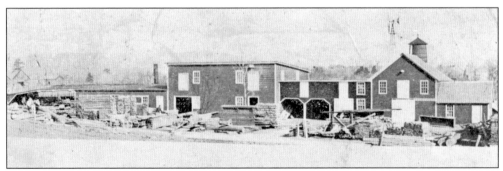

Lumber is stacked up in front of Aussem's Mill in this portion of a 1906 postcard. Located on Bridge Street (Route 396), the sawmill, run by John Aussem, produced boards, lathes, and shingles. In the fall, the mill turned the local apple crop into vinegar and cider for the Albany market. Aussem's was also the location of an electric generator that powered the first street lighting in South Bethlehem in 1907. Eventually, the mill burned to the ground. (TOB.)

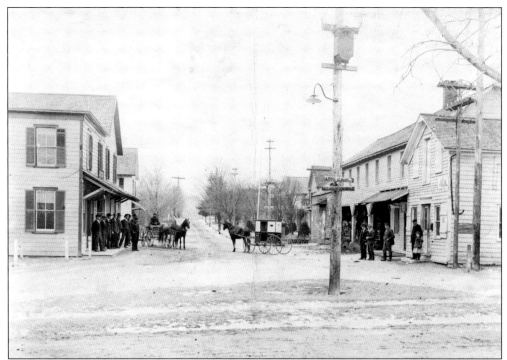

In 1920, South Bethlehem was a bustling community. Looking down South Street from Bridge Street, one notes the prominent electric light and telephone poles. South Bethlehem boasted telephone service in 1904 and streetlights by 1907, with the electric generating station located at Aussem's Mill. The signs on the telephone pole direct one to Capitol Albany and Callanans Corners. (TOB.)

Bundled up against the cold, a group of young women gets ready for a ride on the hamlet's smaller bobsled about 1915. The sled, with its wooden runners, was steered by pulling on the ropes attached to the front runners. (TOB.)

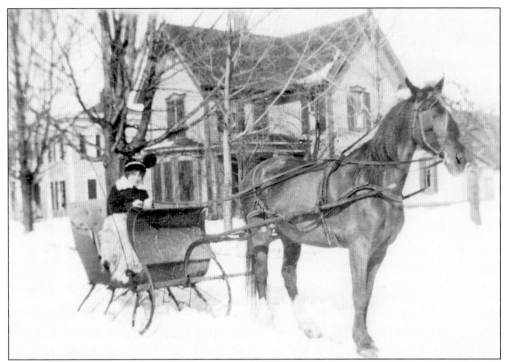

In wintertime, before automobiles prevailed, the horse and sleigh would have been a common sight around town. Sleighs were relatively easy to maneuver on Bethlehem's snow-covered streets. The photograph was taken about 1910 on South Street. The prominent house in the background still stands today, while the one to the left, the Griffin family house, burned in the 1970s. (TOB.)

The South Bethlehem railroad station was part of a bustling hamlet. Howell & Tenney's 1886 *Bi-Centennial History of Albany* reports that "the village has 30 dwellings, 33 families, 135 inhabitants, M.E. church, school-house, 2 stores, shoe shop, harness, blacksmith and wheelwright shop, barber's room and saloon. It has a band of 12 musicians with O.S. Jolley as leader." The station, located in the ravine west of South Street, provided service on the West Shore Railroad to Voorheesville and points west. Passenger service stopped in 1959. (TOB.)

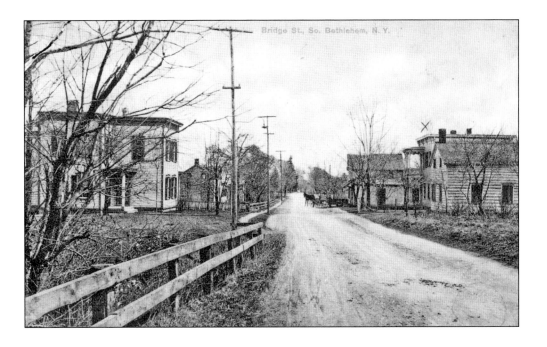

Two postcards show the rural lanes of the hamlet. Above is Bridge Street looking east in a card postmarked September 29, 1909. The house on the left still stands today. The card below shows Church Street and was probably taken from the top of the hill at Bridge Street. In view are the steeple of the Methodist church and the homes nestled about it. (Above, BHA; below, courtesy of Janet Vine.)

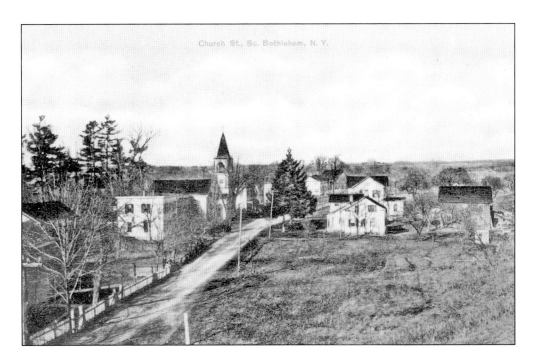

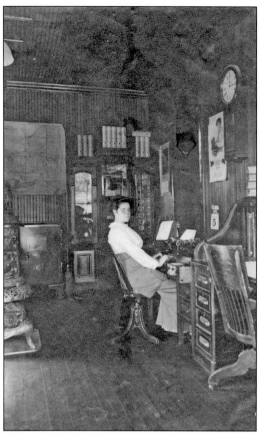

At left, Katie Ladd works in the office of the Callanan Road Improvement Company, which is pictured below. Peter Callanan saw a great opportunity to match Bethlehem's natural stone resources with the growing railroad lines. He also foresaw the need for improved road surfaces and a state highway system. To that end, he founded the Callanan Road Improvement Company in 1883 with partners Dr. J.R. Davidson, a local physician; Phillip Scharhem, a local store owner; and John Newton Briggs, who owned large icehouses in Coeymans. Their initial quarry investment provided crushed ballast stone to the West Shore Railroad and others. In 1895, his company was awarded the first contract for a state road let by the state. When Peter Callanan died in 1896, his wife, Hannah Whitbeck Callanan, played an important role in the company. In 1902, the Callanan company was thriving, with expansion plans in the works. Disaster struck on December 28 when the mill burned down. Several of the stockholders wanted to sell out and not try to reopen. Under Hannah's leadership, the company held together, and the mill was rebuilt with modern machinery. (Both, TOB.)

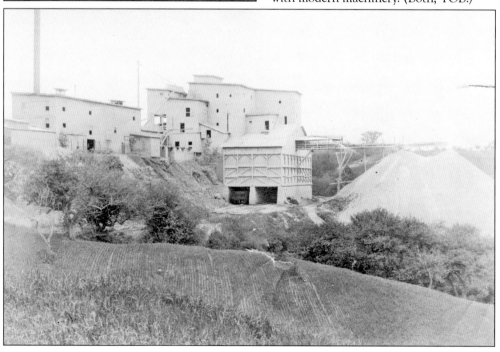

At right, a man works at Callanan's quarry. Below is a postcard view of the quarry and beyond to the hamlet. May 1909 brought disaster. A premature explosion occurred at the quarry that killed 29 men, including Hannah Callanan's sons Charles and John. In an ironic twist, the *Altamont Enterprise* reported that just the year before in 1908 John Callanan, then president and manager of the company, had "decided to put in one giant blast and loosen enough stone for the monster crushers for months." After this giant blast, invited guests were treated to a lobster and clam spread. After the 1909 disaster, Hannah brought in her brother-in-law John Callanan to keep the company going. Hannah died at age 92 in 1948. Today, while no longer a family-run business, Callanan Industries continues to be a leading supplier of road-paving materials. (Right, TOB; below, courtesy of Janet Vine.)

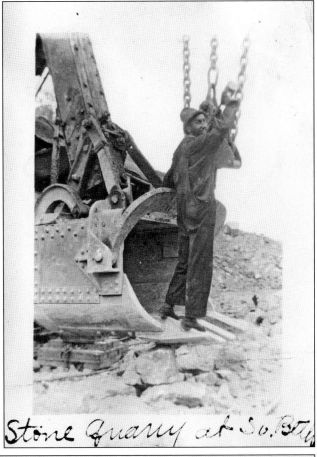

Stone Quarry at So. Beth

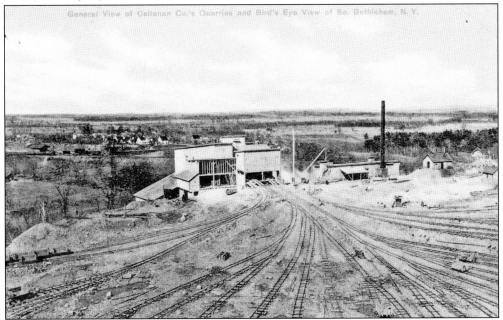

General View of Callanan Co.'s Quarries and Bird's Eye View of So. Bethlehem, N. Y.

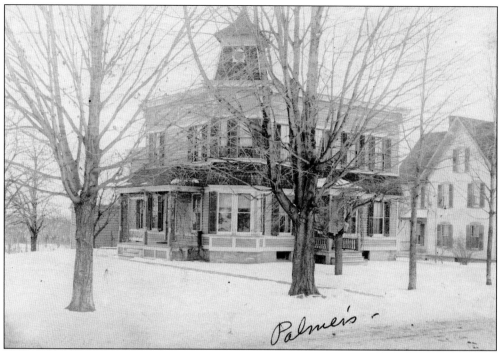

In the photograph above, the stately Palmer house on South Street is shown about 1920; it still stands today. Many of the old homes in the hamlet, especially along South Street, were built for upper-level employees of the Callanan Road Improvement Company. In contrast, the postcard below shows the quarters of Callanan's many transient and contract laborers. These men did the hard, manual labor before the days of mechanical shovels and drills. Located in the ravine near the quarry, this was where as many as 150 men lived at a time, with a commissary nearby. (Above, TOB; below, courtesy of Janet Vine.)

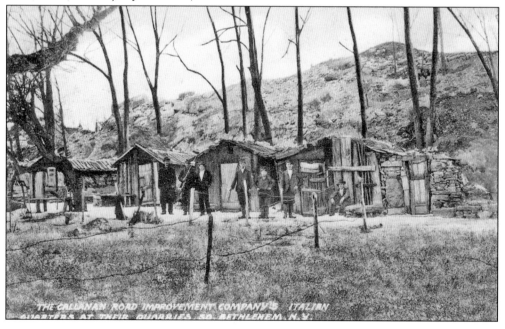

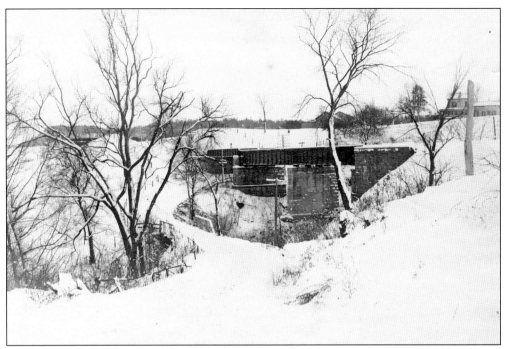

A pair of snowy scenes from about 1920 show the curve on lower South Street. The photograph above looks south on the road toward the Callanan Road Improvement Company. The bridge carried the West Shore Railroad over the ravine and into the South Bethlehem station. In the distance on the right is a Callanan farmhouse that still stands today. The bridge has long since been removed, although the stone abutments can still be seen. Below, the view looks north with the old house on the right still standing today. (Both, TOB.)

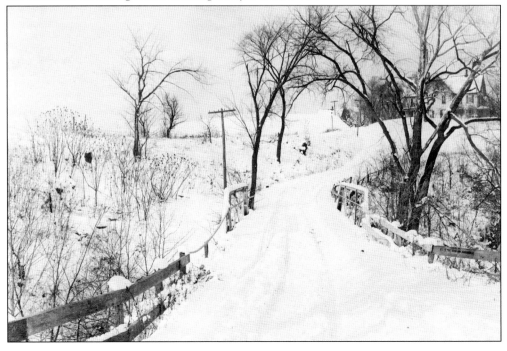

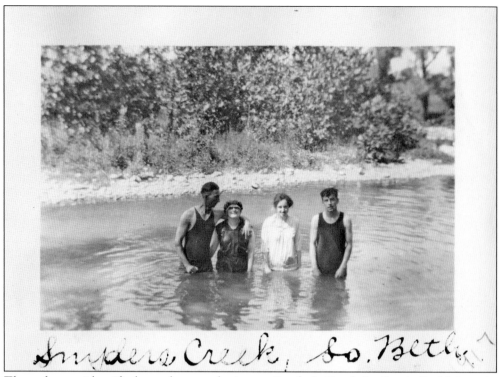

Snyders Creek, So. Beth.

These four unidentified people are relaxing at Snyder's Creek in South Bethlehem in 1917. (TOB.)

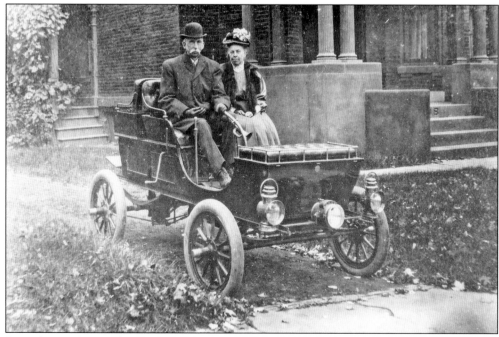

Dr. and Mrs. J.R. Davidson get ready to go in their runabout automobile about 1900. The physician was a well-known presence in the hamlet and an investor in Peter Callanan's quarry. (TOB.)

BIBLIOGRAPHY

Altamont Enterprise, July 1888 to December 2008, http://historicnewspapers.guilpl.org.

Bennett, Allison. *Times Remembered*. Delmar, NY: Newsgraphics, 1984.

———. *More Times Remembered*. Delmar, NY: Newsgraphics, 1987.

Brewer, Floyd, senior ed. *Bethlehem Revisited: A Bicentennial Story 1793–1993*. Bethlehem, NY: Town of Bethlehem Bicentennial Commission, 1993.

Christoph, Florence, and Peter R. Christoph, eds. *Records of the People of the Town of Bethlehem*. Selkirk, NY: Town of Bethlehem Historical Association, 1982.

David Rumsey Map Collection website, http://www.davidrumsey.com.

Howell, George Rogers, and Jonathan Tenney. *Bi-centennial History of Albany County*. New York: Munsell, 1886.

Munsell, Joel. *The Annals of Albany*. Albany, NY: Joel Munsell, 1869.

Parker, Amasa. *Landmarks of Albany County*. Syracuse, NY: D. Mason, 1897.

Discover Thousands of Local History Books Featuring Millions of Vintage Images

Arcadia Publishing, the leading local history publisher in the United States, is committed to making history accessible and meaningful through publishing books that celebrate and preserve the heritage of America's people and places.

Find more books like this at
www.arcadiapublishing.com

Search for your hometown history, your old stomping grounds, and even your favorite sports team.

Consistent with our mission to preserve history on a local level, this book was printed in South Carolina on American-made paper and manufactured entirely in the United States. Products carrying the accredited Forest Stewardship Council (FSC) label are printed on 100 percent FSC-certified paper.